CONFESSIONS OF AN ART ADDICT

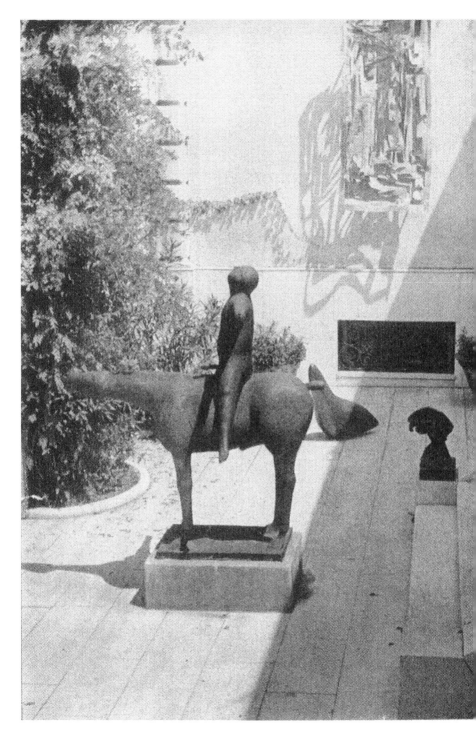

My Marini

PEGGY GUGGENHEIM

CONFESSIONS
OF AN ART ADDICT

Foreword by Gore Vidal

Introduction by Alfred H. Barr, Jr.

THE ECCO PRESS

For Alfred H Barr Jr

Copyright © 1960 Peggy Guggenheim
Foreword Copyright © 1979 by Gore Vidal. Reprinted by permission of William Morris Agency, Inc. On behalf of the Author.

THE ECCO PRESS
100 West Broad Street
Hopewell, New Jersey 08525

Printed in the United States of America

Library of Congress Cataloging-in-Publication Data

Guggenheim, Peggy, 1898–1979
 Confessions of an art addict / Peggy Guggenheim. — 1st
Ecco ed.
 p. cm.
 Autobiographical.
 Updated ed. of : Out of this century. 1st ed. 1980.
 Includes index.
 ISBN 0-88001-576-4
 1. Guggenheim, Peggy, 1898–1979. 2. Art patrons—United
States—Biography. I. Guggenheim, Peggy, 1898–1979 Out of
this century. II. Title.
 N5220.G886A3 1997
 709'.2—dc21 97-15461

9 8 7 6 5 4 3 2

FIRST ECCO EDITION 1997

CONTENTS

ILLUSTRATIONS

*The photograph of the author, facing page 32, is by Curtis Bell;
those of Laurence Vail, Yves Tanguy and Marcel Duchamp, between
pages 32–3, are by Isabey, Man Ray and Sidney Waintrob respectively;
the one of Art of This Century, facing page 33, is by George Karger
Pix. The photograph of Max Ernst, facing page 48, is by Leonar;
those facing pages 49, 80 and 81 are by Cacco, Sidney Waintrob and
Jerome Zerbe respectively, and those of the author, facing pages 112–13,
by Cacco and by Roloff Beny, as is the one facing page 145. The
Palazzo Venier dei Leoni, facing page 144, is by Jerry Harper.*

Foreword

BY GORE VIDAL

In the winter of 1945–46 I was a Warrant Officer in the Army of the United States, stationed at Mitchell Field, Long Island. I had just finished a first novel, *Williwaw*, based on my experiences as the first mate of an army freight supply ship in the Aleutians. Before I enlisted in the army at seventeen, I had lived in Washington, D.C. My family was political-military. I give these little personal facts to set the scene for my first meeting with Peggy Guggenheim.

In the early part of that winter I had met Anaïs Nin. I was twenty. She was forty-two. Our long and arduous relationship, or Relationship, began in the cold, as the sweet singer of Camelot would say. Anaïs was a shining figure who looked younger than she was; spoke in a soft curiously accented voice; told lies which for sheer beauty and strangeness were even better than the books she wrote—perhaps because what she wrote was always truthful if not true while what she said was intended only to please—herself as well as others.

"I shall take you to a party, *chéri*," she announced. We were in the five-floor Greenwich Village walk-up where she lived with her husband (a banker who made movies and engravings and helped Anaïs play at being a starving Bohemian). Anaïs always called me "*chéri*" with a slightly droll inflection. Since I had not yet read Colette, it was several years before I got the joke. But then she did not get all my jokes either. So "*chéri*" and Anaïs went to Peggy Guggenheim's house (described on pages 90–91) and "*chéri*" has never forgotten a single detail of that

bright, magical (a word often used in those days) occa-
sion. In a sense, like the character in *Le Grand Meaulnes*,
I still think that somewhere, even now, in a side street of
New York City, that party is still going on and Anaïs is
still alive and young and *"chéri"* is very young indeed,
and James Agee is drinking too much and Laurence Vail
is showing off some bottles that he has painted having
first emptied them into himself as part of the creative
process and André Breton is magisterial and Léger looks
as if he himself could have made one of those bits of ma-
chinery that he liked to paint; and a world of color and
humor is still going on—could be entered again if only
one had not mislaid the address. Recently I came across
an old telephone book. I looked up Anaïs's number of
thirty-five years ago. Watkins something-or-other. I
rang the number; half-expected her to answer. If she had,
I'd have asked her if it was still 1945 and she would say,
Of course. What year did I think it was? And I'd say, No,
it's 1979, and you're dead. (*"Chéri"* was never noted for
his tact.) And she would laugh and say, Not yet.

Not yet. Well, "yet" is here. And so is Peggy Guggen-
heim. When I first saw her she was smiling—a bit sleep-
ily. I remember something odd hanging about her neck
. . . Barbarous jewelry? My memory's less perfect than I
thought. Actually, I remember Agee's red-rimmed
drinker's eyes and Vail's white streaming hair rather
more vividly than I do Peggy, who drifted effortlessly
through her own party, more like a guest than a hostess.

There. I am getting, as it were (as Henry James would
say), *some*thing of Peggy's aura then and now. Although
she gave parties and collected pictures and people, there
was—and is—something cool and impenetrable about
her. She does not fuss. She is capable of silence, a rare

gift. She listens, an even rarer gift. She is a master of the
one-liner that deflates some notion or trait of character
or person. As I write this, I am trying to think of a bril-
liant example; and fail. So perhaps it is simply the dry
tone—the brevity with which she delivers her epi-
taphs—that one remembers with pleasure.

Peggy never liked Anaïs. For some reason, to this
day, I have never asked her why. Last year, shortly be-
fore Peggy's eightieth birthday, we were sitting in the
salone of her *palazzo* on Venice's Grand Canal (writing
that sentence I begin to see Peggy Guggenheim as the
last of Henry James's transatlantic heroines, Daisy
Miller with rather more balls), and Peggy suddenly said,
"Anaïs was very stupid, wasn't she?" It is the artful mak-
ing of statements in the form of a question that sets
apart Peggy's generation from the present age where
there are no questions, only thundering self-serving as-
sertions.

"No," I said. "She was shrewd. And she got exactly
what she wanted. She set out to be a legendary figure."
Legend was a word that Anaïs always used with rever-
ence. "And she lived long enough to see herself a sort of
heroine to the women's liberation movement."

"That may be shrewd," said Peggy—in the late after-
noon light the sleepy narrow eyes suddenly shone like
cats' eyes—"but it seems a stupid thing to want to be."

Now Peggy has been transformed by time (with a bit
of help from her own shrewd nature) into a legend of the
very same variety that Anaïs had in mind, a high roman-
tic Murgeresque mind. Yet, at eighty, the legendary
Peggy keeps a sharp eye on a world that is declining
rather more rapidly than she is. After all, Venice is sink-
ing, literally, beneath her unfinished white *palazzo*. If

One who believes only in self is only reality.

the ultimate dream of the solipsist is to take the world with him when he dies, Peggy may very well end by taking Venice out of this world and into her own world where that party still goes on and everyone is making something new and art smells not of the museum but of the maker's studio.

Last summer I asked, "How are you?" Polite but real question: she'd been in considerable pain with some disturbance of the arteries. "Oh," she said, "for someone dying, not bad."

It seems to me that this memoir—artful rather than artless, though the unknowing will not get the point to the art—reflects a world as lost now as the Watkins number that did not ring for lack of a digit. But since the prose in this volume is all Peggy's own, something has been salvaged. One hears in these lines the brisk yet drawling voice; sees the sudden swift side-long glance that often accompanies her swift judgments; takes pleasure if not in her actual self, in its shadow upon the page.

I last saw Peggy looking very shadowy on Italian television. Venice was celebrating her eightieth birthday; or at least that part of Venice which has not sunk into sloth as opposed to the Adriatic.

The camera came in for a very close shot of Peggy's handsome head. An off-camera voice asked her what she thought of today's Italian painters. The eyes shifted toward the unseen questioner; the half smile increased by a fraction. "Oh," she said, "they're very bad." Then always the Jamesian heroine, she added, "Aren't they?"

Consternation throughout Italy. The heroine of *The Golden Bowl* had shattered the bowl—and prevailed once again.

[1979]

10

Introduction

BY ALFRED H BARR JR

Courage and vision, generosity and humility, money and time, a strong sense of historical significance, as well as of aesthetic quality—these are factors of circumstance and character which have made Peggy Guggenheim an extraordinary patron of twentieth century art. On ground rocked by factionalism, she has stood firm, taking no sides, partisan only of the valuable revolution. Consequently we find in her collection works which are diametrically opposed in spirit and form, even though they may seem to be alike in their radical strangeness.

The collection is Peggy Guggenheim's most durable achievement as an art patron, but it is quite possibly not her most important. I have used the threadbare and somewhat pompous word 'patron' with some misgivings. Yet it is precise. For a patron is not simply a collector who gathers works of art for his own pleasure or a philanthropist who helps artists or founds a public museum, but a person who feels responsibility towards both art and the artist together and has the means and will to act upon this feeling.

Peggy Guggenheim had no early interest in modern art. In fact, she loved and studied Italian Renaissance painting, particularly that of Venice. Berenson's books were her guide and perhaps they confirmed that sense for the history of art which she carried into the twentieth century, the very point in time and taste at which her mentor stopped.

Then in the late 'thirties, largely as an amateur's diversion, she opened an *avant-garde* gallery in London. Marcel Duchamp was her chief adviser (the same who

11

in New York twenty years before had counselled Katherine Dreier in her creation of the pioneering *Société Anonyme*). Guggenheim Jeune, as she humorously called the enterprise, gave several excellent exhibitions, among them England's first one-man shows of Kandinsky, the first abstract expressionist, and Yves Tanguy, the surrealist painter. At the same time, the gallery gave their first exhibitions to young artists such as John Tunnard, the best of the new English abstract painters of the period. Yet these achievements seemed to her too impermanent.

Early in 1939 Peggy Guggenheim 'had the idea of opening a modern museum in London', a project which must have seemed urgent, the director of the Tate Gallery having not long before declared for customs purposes that sculptures by Calder, Arp, Pevsner and others, which Guggenheim Jeune was importing for a show, were not works of art at all.

With her usual flair for enlisting the ablest help, she asked Herbert Read, now Sir Herbert, to become the director of this projected museum. Read, generally considered the leading English authority on modern art, was persuaded to resign his editorship of the highly respectable *Burlington Magazine* in order to assume his new and adventurous position. The patron and the director drew up an ideal list of works of art for the new museum—a list which was also to serve as the basis for the opening exhibition. A building was found, but before the lease could be signed World War II began and the dream faded, or better, was suspended.

In Paris during the winter of the 'phony war' Peggy Guggenheim, only a little daunted, kept on adding to the collection, 'buying a picture a day' with the advice

of her friends Duchamp, Howard Putzel and Nellie van Doesburg. She even rented space for a gallery in the Place Vendôme, but meanwhile the cool war turned hot. The Brancusi *Bird in Space* was bought as the Germans were nearing Paris.

During the first year of the German occupation the collection was safeguarded in the Grenoble museum; but it was not shown there because the director feared the reprisals of the collaborationist Vichy régime. Finally, in the spring of 1941, the collection and its owner reached New York.

Thanks largely to the influx of refugee artists and writers from Europe, New York during the war supplanted occupied Paris as the art centre of the Western world. Later, most of the Europeans returned, particularly to France; yet, in the post-war world, Paris seems clearly less pre-eminent and New York remains a contestant partly because of the rise of the most internationally respected group of painters so far produced in the United States. In their development, Peggy Guggenheim, as patron, played an important, and in some cases, a crucial role.

She had been frustrated in London, in Paris and in Grenoble, but in New York, thanks to its distance from the conflict, she was able temporarily to realize her vision. With the advice of the surrealist painter, Max Ernst, and the poet André Breton, she continued to add to her collection and published a brilliant catalogue, *Art of this Century*, the title she also gave to her new gallery.

Art of this Century immediately became the centre of the vanguard. Under the influence of Duchamp, Ernst and Breton, the surrealist tradition was strong but never exclusive. The great abstract painter, Piet Mondrian,

13

was also welcome and took an active part as a member of the juries which chose the recurrent group shows of young American artists.

In the first 'Spring Salon', 1943, three young painters stood out: William Baziotes, Robert Motherwell and Jackson Pollock. Within a year all three were launched by the gallery with one-man shows. Pollock's exhibition, with an enthusiastic catalogue preface by James Johnson Sweeney, won special admiration. Then, again with remarkable prescience, *Art of this Century* gave shows to Mark Rothko, Clyfford Still and others. I say prescience because although their work had not come to full maturity at that time, Rothko, Still, Baziotes, Motherwell, Pollock and two or three others are now recognized in the United States and increasingly in Europe as the chief pillars of the formidable new American school.

Early pictures by these painters, bought by Peggy Guggenheim out of their shows seventeen years ago, may be seen in her collection today. Jackson Pollock, the most renowned of them, is represented by many works, though not by his largest, a mural commissioned by his patron for the lobby of her New York residence. Pollock she also helped financially, and when in 1947 *Art of this Century* closed she helped to place the artists in other galleries.

Today, in Venice, Peggy Guggenheim, her collection and her exhibition gallery continue to work. Visitors who study the collection with the sounds of the Grand Canal in their ears should know something of the history of the collector as patron—particularly Americans, who owe a special debt to their countrywoman, Peggy Guggenheim. 1956

GILT-EDGED CHILDHOOD

CHAPTER ONE

GILT-EDGED CHILDHOOD

In 1923, I began to write my memoirs, but did not get very far. They began like this: 'I come from two of the best Jewish families. One of my grandfathers was born in a stable like Jesus Christ, or, rather, over a stable in Bavaria, and my other grandfather was a peddler.' To go on where I left off, if my grandfathers started life modestly they ended it sumptuously. My stable-born grandfather, Mr Seligman, came to America in steerage, with forty dollars in his pocket. He began his fortune by being a roof shingler and later by making uniforms for the Union Army in the Civil War. Later he became a renowned banker. Socially he got way beyond my other grandfather, Mr Guggenheim the peddler, who was born in Ober-Lengnan in German Switzerland. Mr Guggenheim far surpassed Mr Seligman in amassing an enormous fortune and buying up most of the copper mines of the world, but he never succeeded in attaining Mr Seligman's social distinction. In fact, when my mother married Benjamin Guggenheim the Seligmans considered it a *mésalliance*. To explain that she was marrying into the well-known smelting family, they sent a cable to their kin in Europe saying, 'Florette engaged Guggenheim smelter.' This became a great family joke, as the cable misread, *Guggenheim smelt her.*

By the time I was born, the Seligmans and the

17

Guggenheims were extremely rich. At least the Guggenheims were, and the Seligmans hadn't done so badly. My grandfather, James Seligman, was a very modest man who refused to spend money on himself. He lived sparsely and gave everything to his children and grandchildren. Most of his children were peculiar, if not mad. That was because of the bad inheritance they received from my grandmother. My grandfather finally had to leave her. She must have been objectionable. My mother told me that she could never invite young men to her home without a scene from her mother. My grandmother went around to shopkeepers and, as she leaned over the counter, asked them confidentially, 'When do you think my husband last slept with me?'

My mother's brothers and sisters were very eccentric. One of my favourite aunts was an incurable soprano. If you happened to meet her on the corner of Fifth Avenue while waiting for a bus, she would open her mouth wide and sing scales, trying to make you do as much. She wore her hat hanging off the back of her head or tilted over one ear. A rose was always stuck in her hair. Long hatpins emerged dangerously, not from her hat, but from her hair. Her trailing dresses swept up the dust of the streets. She invariably wore a feather boa. She was an excellent cook and made beautiful tomato jelly. Whenever she wasn't at the piano, she could be found in the kitchen or reading the ticker-tape. She was an inveterate gambler. She had a strange complex about germs and was forever wiping her furniture with lysol. But she had such extraordinary charm that I really loved her. I cannot say her husband felt as much. After he had fought with her for over thirty years, he tried to kill her and one of her sons by hitting them with a golf club. Not

succeeding, he rushed to the reservoir where he drowned himself with heavy weights tied to his feet.

My most attractive uncle was a very distinguished gentleman of the old school. Being separated from his wife, who was as rich as he, he decided to live in great simplicity in two small rooms and spend all his money on fur coats which he gave away to girls. Almost any girl could have one for the asking. He wore the *Légion d'honneur* but would never tell us why he had been decorated.

Another uncle lived on charcoal, which he had been eating for many years, and as a result his teeth were black. In a zinc-lined pocket he carried pieces of cracked ice which he sucked all the time. He drank whisky before breakfast and ate almost no food. He gambled heavily, as did most of my aunts and uncles, and when he was without funds he threatened to commit suicide to get more money out of my grandfather. He had a mistress whom he concealed in his room. No one was allowed to visit him until he finally shot himself, and then he could no longer keep the family out. At the funeral my grandfather greatly shocked his children by walking up the aisle with his dead son's mistress on his arm. They all said, 'How can Pa do that?'

There was one miserly uncle who never spent a cent. He arrived in the middle of meals saying he didn't want a thing, and then ate everything in sight. After dinner he put on a frightening act for his nieces. It was called 'the snake'. It terrified and delighted us. By placing lots of chairs together in a row and then wriggling along them on his stomach he really produced the illusion. The other two uncles were nearly normal. One of them spent all his time washing himself and the other one wrote

plays that were never produced. The latter was a darling and my favourite.

My other grandfather, Meyer Guggenheim, lived happily with his step-sister, to whom he was married. They brought up an even larger, if less eccentric, family than the Seligmans. There were seven brothers and three sisters. They produced twenty-three grand-children. My one recollection of this gentleman is of his driving around New York in a sleigh with horses. He was unaccompanied and wore a coat with a sealskin collar and a cap to match. He died when I was very young.

I was born in New York City on East 69th Street. I don't remember anything about this. My mother told me that while the nurse was filling her hot water bottle, I rushed into the world with my usual speed and screamed like a cat. I was preceded by one sister, Benita, who was almost three years older than I. She was the great love of my early life, in fact of my entire immature life. We soon moved to a house on East 72nd Street, near the entrance to the Park. Here my second sister Hazel was born when I was almost five. I was fiendishly jealous of her.

My childhood was excessively unhappy: I have no pleasant memories of any kind. It seems to me now that it was one long protracted agony. When I was very young I had no friends. I didn't go to school until I was fifteen. Instead I studied under private tutors at home. My father insisted that his children be well-educated and saw to it that we acquired 'good taste'. He himself was keen on art and bought a lot of paintings. Almost

the only toys I can remember are a rocking horse with an enormous rump and a doll's house containing bear-skin rugs and beautiful crystal chandeliers. I also had a glass cabinet filled with tiny hand-carved ivory and silver furniture, which had an old-fashioned sculptured brass key. I kept the cabinet locked and allowed no one to touch my treasures.

My strongest memories are of Central Park. When I was very young my mother used to take me driving there in an electric brougham. Later I rode in the Park in a little foot-pedalled automobile. In the winter I was forced to go ice skating, which caused me to suffer agonies. My ankles were too weak and my circulation much too bad. I shall never forget the excruciating pain I felt from the thawing of my toes, when, after returning from the lake, I clung to a stove which was in a little cabin intended for skaters.

Not only was my childhood excessively lonely and sad, it was also filled with torments. I once had a nurse who threatened to cut out my tongue if I dared to repeat to my mother the foul things she said to me. In desperation and fear I told my mother, and the nurse was dismissed at once. Also I was not at all strong and my parents were perpetually fussing about my health. They imagined I had all sorts of illnesses and were forever taking me to doctors. When I was about ten I got an attack of acute appendicitis and was rushed off to the hospital at midnight and operated on.

Not long after this I had a bad accident while riding in Central Park. As I passed under a bridge some boys on roller skates overhead made such a noise that my horse bolted. I lost my seat, fell to the ground and was dragged for quite a distance. I could not disengage my

foot from the stirrup and my skirt caught on the pommel. Had I been riding astride this never would have occurred. I not only hurt my foot but I seriously injured my mouth. My jaw was broken in two places and I lost a front tooth. A policeman, finding the tooth in the mud, returned it to me in a letter, and the next day the dentist, after disinfecting it, pushed it up into its original position. This did not end my troubles. My jaw had to be set. During the operation a great battle took place among the attending surgeons. Finally, one of them triumphed over the other and shook my poor jaw into shape. The vanquished dentist never got over this. He felt he had superior rights over my mouth, as he had been straightening my teeth for years. The only good that came out of all this was that it put an end to the agonies I had been suffering in the process of being beautified. Now that had to end. The first danger incurred was the possibility of being blood-poisoned. When that passed, the only risk I ran was of getting hit in the mouth and losing my tooth again before it was firmly implanted. In those days my sole opponents were tennis balls, so that when I played tennis I conceived the bright idea of tying a tea strainer in front of my mouth. Anyone seeing me must have thought I had hydrophobia. When it was all over, my father received a bill for seven thousand five hundred dollars from the dentist who had never admitted his defeat. My father persuaded this gentleman reluctantly to accept two thousand.

In spite of all the trouble I went through to preserve the tooth, I knew it could not remain with me for more than ten years, after which time its root would be completely absorbed and the tooth would have to be re-

placed with a porcelain one. I was prophetic in gauging its life, may I say, almost to the day. After ten years I made an appointment to have it replaced before it fell out, which it did exactly two days before the dentist expected me.

My sister Benita was the only companion of my childhood and I therefore developed a great love for her. We were perpetually chaperoned by French governesses, but they were always changing, so that I can barely remember them. Hazel, being so much younger, had a nurse and lived a distinctly separate life. I don't remember my mother at all at this age.

When I was five or six my father began to have mistresses. A trained nurse lived in our house in order to massage my father's head, since he suffered from neuralgia. According to my mother, this nurse was the cause of all her troubles in life, as she somehow influenced my father for the bad, without actually ever having been his mistress. It took my mother years to free herself of the poisonous presence of this woman in our household, for my father depended on her so much for the massage. However, we finally got rid of her, but it was too late. From then on my father had a whole series of mistresses. My mother took it as a great offence that my aunts remained friendly with this nurse and had long feuds with them for befriending her. All this affected my childhood. I was perpetually being dragged into my parents' troubles and it made me precocious.

My father always called me Maggie, only much later did I become Peggy. He had beautiful jewellery made for us which he designed himself. In honour of my name, Marguerite, he once presented me with a little bracelet

CONFESSIONS OF AN ART ADDICT

that looked like a daisy chain, made of pearls and diamonds. My mother received more substantial presents, among them a magnificent string of pearls.

I adored my father because he was fascinating and handsome, and because he loved me. But I suffered very much, as he made my mother unhappy, and sometimes I fought with him over it. Every summer he took us to Europe. We went to Paris and to London, where my mother visited hundreds of French and English Seligmans, and we also went to fashionable watering-places.

My father engaged a lady called Mrs Hartman to teach us art. We brought her to Europe with us and it was her duty to make us cultured. She took us to the Louvre, the Carnavalet and to the châteaux of the Loire. She taught us French history, and also introduced us to Dickens, Thackeray, Scott and George Eliot. She also gave us a complete course in Wagner's operas. I am sure Mrs Hartman did her best to stimulate our imaginations, but personally, at that time, I was more interested in other things. For one, I was infatuated with a friend of my father's called Rudi. He was a typical roué and I can't imagine now why he fascinated me. I was so much enamoured of him that I wrote mad letters about my passion, in which I said my body was nailed to the fire of the cross. When Rudi married one of my cousins, whom my mother had brought to Europe with her, and whose unfortunate marriage I fear she and my father arranged, I wept bitter tears and felt completely let down. I complained, saying he had no right to trifle with the affections of two women at once. At this time I must have been about eleven.

One day when I was having tea with Benita and my governess at Rumpelmeyer's in Paris, I found myself

24

fascinated by a woman at the next table. I could not take my eyes off her. She seemed to react in the same way to us. Months later, after I had been tormenting my governess to tell me who my father's mistress was, she finally said, 'You know her'. Like a flash, the face of the woman at Rumpelmeyer's came to my mind and when questioned, my governess admitted I was right.

This woman was neither pretty nor young. I never understood my father's infatuation for her. But she had the same agreeable quality (maybe sensuous) of his trained nurse. She was dark and resembled a monkey. She had ugly teeth which my mother used to refer to with contempt as 'black'. We met this woman everywhere in Paris. It was most awkward. One day at the dressmaker Lanvin, my mother, accompanied by Benita and me, walked into a room where the woman was seated. My mother rushed out of the room and we followed her. The Lanvin staff, with correct French understanding, gave us another *salle* to ourselves.

T.M., as we used to call her, wore the most elegant clothes. She had one suit which was made entirely of baby lamb fur. One day when we were taking our morning walk in the Bois on the Avenue des Acacias, we met her wearing this costume. My mother protested to my father regarding his extravagance. To console her he gave her money to have the same suit made for herself. Being a good business women she accepted the money, but instead she invested it in stocks and bonds.

T.M. had been preceded by another lady. This lady, whom I never saw, nearly succeeded in marrying my father. In fact, my mother had come to the point of divorcing him. But the whole Guggenheim family came in groups and individually, begging her to reconsider

her decision. We had streams of visitors all day long. Their one idea was to avoid this catastrophe. Finally my mother gave in. I don't know when the affair ended—it did not last long—but I do know that the disappointed mistress received a large consolation prize, and to this day part of my income goes to her regularly twice a year. T.M. was followed by a young blonde singer.

In 1911, my father had more or less freed himself from us. He had left his brothers' business and had his own in Paris. This was a move he doubtless made to be able to live a freer life, but its consequences were more far-reaching than he ever realized. By leaving his brothers and starting his own business, he forfeited his claims to an enormous fortune. He had an apartment in Paris and was interested in or owned a concern which built the elevators for the Eiffel Tower. In the spring of 1912, he was finally to return to us after an eight months' absence. He had a passage on some steamship which was cancelled because of a strike of the stokers. By this mere accident of fate he was to lose his life: he booked a place on the ill-fated *Titanic*.

On April 15 the morning papers announced the dramatic sinking of this gigantic liner on her maiden voyage. In order to make a record trip for the White Star Line, Bruce Ismay, the chairman of the company, who was on board, and the captain, ignoring the warning of icebergs, forged their way ahead, completely disregarding the dangers. The *Titanic* rushed to her doom. In the middle of the night she encountered an iceberg which ripped her bottom open. Within two and a half hours she sank. Unluckily the S.S. *Californian*, which was only ten miles away, had closed down her wireless. There were not nearly enough lifeboats, and,

for reasons never explained, several of those that got away were barely filled, and passengers who were left on board when the ship sank were frozen in the icy water before Captain Rostrum, of the S.S. *Carpathia*, could come to their rescue. Only about 700 people were saved out of 2,200. The whole world was shaken by this disaster. Everyone waited breathlessly for the *Carpathia* to dock to find out who were the lucky survivors. We wired Captain Rostrum to find out if my father was on his ship. He wired back: 'No'. For some reason I was told this, while my mother was kept in ignorance until the last minute. Then two of my cousins went down to meet the survivors. They met my father's mistress.

With my father there died a lovely young Egyptian, Victor Giglio, who was his secretary. He had had a hard time in the past and was happy to have been engaged by my father, thinking his troubles were ended. I was attracted to this beautiful boy, but my father did not approve of my ardour. A steward of the *Titanic*, a survivor, came to see us to deliver a message from my father. He said that my father and his secretary had dressed in evening clothes to meet their death. They had wanted to die as gentlemen, which they certainly did, by gallantly giving their places to women and children.

After my father's death I became religious. I attended the services in Temple Emanu-el regularly, and took great dramatic pleasure in standing up for the *Kaddish*, the service for the dead. My father's death affected me greatly. It took me months to get over the terrible nightmare of the *Titanic*, and years to get over the loss of my father.

When he died, he left his business affairs in an awful

muddle. Not only had he lost a vast fortune by discontinuing his partnership with his brothers, but the money he should have had, some eight million dollars, he had lost in Paris. The small amount that was left was tied up in stocks that were yielding no interest and were at such a low ebb that they could not be sold. However, my mother did not know this and we continued living on the same scale. My uncles, the Guggenheims, very gallantly advanced us any funds we needed, keeping us in supreme ignorance. Finally, my mother discovered the truth and took drastic steps to end the false situation. To begin with, she started spending her own personal fortune. We moved to a cheaper apartment with fewer servants. She sold her paintings, her tapestries and her jewellery. She managed very well, and although we were never poor, from that time on I had a complex about no longer being a real Guggenheim. I felt like a poor relative and suffered great humiliation thinking how inferior I was to the rest of the family. My grandfather Seligman died four years after my father, and then my mother inherited a small fortune from him. We immediately reimbursed my father's brothers. After seven years my uncles settled my father's estate. They had finally put things into such shape by advancing their own money that my sisters and I each inherited four hundred and fifty thousand dollars and my mother slightly more. Half of what I received was placed in trust and my uncles insisted that I voluntarily do the same with the other half.

During my sixteenth summer, while we were in England, war broke out. We returned to the United

States, and eventually I was sent to school. It was a private school on the West Side for young Jewish girls, and I would walk there every day through Central Park. But after a few weeks I developed whooping-cough and bronchitis and had to spend the winter in bed. I was lonely and neglected, as it was the year of Benita's début and my mother was very busy with her. Somehow I managed to do all my homework alone and kept up with the school course and passed all my exams. I am not at all intellectual and it was a great effort. But I did like reading, and I read constantly in those days.

During my second school year I began to have a social life. I organized a little dance club with my schoolmates and some other girls. To cover the expenses of a monthly ball, we all contributed money. We were permitted to invite one or two boys to come and dance with us. We made a list of the desirable young men in our Jewish circles and then I held a mock auction sale and auctioned them off to the highest bidder, who then had the privilege of inviting them. These parties were gay and really not at all stuffy.

During the summer of 1915, I received my first kiss. It was from a young man who took me out driving every night in my mother's car. He invariably borrowed our automobile to drive home afterwards and would bring it back every morning at seven on his way to the station, when he went to New York to his job. My mother disapproved of my suitor because he had no money. She controlled herself until the night when he kissed me for the first and last time. We were in the garage and as he leaned over me, by mistake he put his arm on the horn. This awoke my mother. She greeted us with a storm of abuse and screamed at us, 'Does he think my car is a

taxi?' Needless to say, I never saw the young man
again. My mother felt triumphant, but several years
later Fate proved her, according to her standards,
entirely in the wrong, as this young man fell heir to a
million dollars.

After graduating from school I was rather at a loose
end. I continued reading with my voracious appetite
and studied courses in history, economics and Italian.
I had one teacher called Lucile Kohn, who had a stronger
influence over me than any other woman has ever had.
In fact, because of her, my life took a completely new
turn. It didn't happen suddenly; it was a gradual
process. She had a passion for bettering the world. I
became radical and finally emerged from the stifling
atmosphere in which I had been raised. It took me a
long time to liberate myself, and although it was not for
several years that anything occurred, the seeds that she
sowed sprouted, branching out in directions that even
she never dreamed of.

In 1918, I took a war job. I sat at a desk and tried to
help our newly-made officers buy uniforms and other
things at a discount. I had to give advice and write out
many cards of introduction. I shared this job with my
friend, Ethel Frank, who had been my most intimate
school companion. When she fell sick, I did all her work
and mine, and the long hours proved too strenuous for
me. I collapsed. It began by my not sleeping. Then I
stopped eating. I got thinner and thinner and more and
more nervous. I went to a psychologist and asked him
if he thought I was losing my mind. He replied, 'Are
you sure you have a mind to lose?' Funny as his reply

was, I think my question was quite legitimate. I used to pick up nearly every match I found and stayed awake at night worrying about the houses that would burn because I had neglected to pick up some particular match. Let me add that all these had been lit, but I feared there might be one virgin among them. In despair my mother engaged Miss Holbrook, my dead grandfather's nurse, to look after me. She accompanied me everywhere. I wandered around, revolving in my brain all the problems of Raskolnikov, thinking how much I resembled this hero of Dostoevsky's *Crime and Punishment*. Finally Miss Holbrook, by sheer force of will, made me think of other things. Little by little I became normal again. During this period I was engaged to a flying officer who was still in this country. I had several fiancés during the war as we were always entertaining soldiers and sailors.

In the summer of 1919, I came into my fortune. I was an heiress and I was independent. My mother was greatly upset. She could no longer control me. The first thing I did was to make an extensive trip all over the United States. I invited Benita's new husband's cousin to chaperon me. We went from Niagara Falls to Chicago and from there to Yellowstone Park, all through California, down to the Mexican border and up the coast to the Canadian Rockies, and then back to Chicago, where I was met by my aviator fiancé, who had been demobilized. He introduced me to his family, who were all Chicagoans, but I did not make a hit. I complained too much about the provincialism of Chicago. As I was leaving on the 'Twentieth Century', he told me it was all off. I was very unhappy because I thought I was in love with him and was patiently wait-

ing for him to make a fortune in the loose-leaf paper business so that he could marry me.

In the winter of 1920, being very bored, I could think of nothing better to do than have an operation performed on my nose to change its shape. It was ugly, but after the operation it was undoubtedly worse. I went to Cincinnati where there was a surgeon who specialized in these beauty operations. He made you choose a plaster model of the nose you preferred. He never was able to give me what I wanted, a nose 'tip-tilted like a flower', something I had read about in Tennyson. During the operation (performed under a local anaesthetic), when I was suffering the tortures of the damned, surrounded by five nurses in white masks, the doctor suddenly asked me to choose again. He could not do what he had planned. It was all so painful I told him to stop and leave things as they were. As a result of the operation my nose was painfully swollen for a long time and I didn't dare set foot in New York. I hid in the Middle West, waiting for the swelling to go down. Every time it rained I knew it beforehand, because my nose became a sort of barometer and would swell up in bad weather. I went to French Lick, Indiana, with a friend and gambled away nearly another thousand dollars, the operation having cost as much.

If Lucile Kohn was responsible for my radical beliefs, my actual liberation came about quite differently from any manner she might have foreseen. One day when I was at my dentist's, I found him in a predicament. His nurse was ill and he was doing all his work alone. I offered to replace the nurse as best I could. He accepted my help, for which he paid me $2.35 a day. I opened the door and answered the telephone. I held instruments

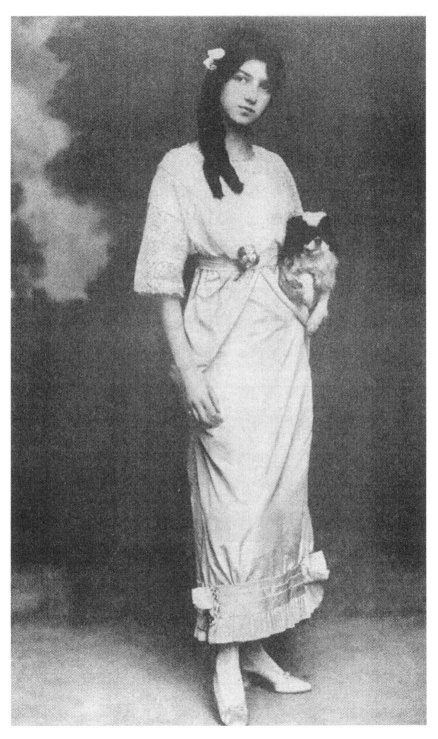

Myself aged fourteen

John Holms

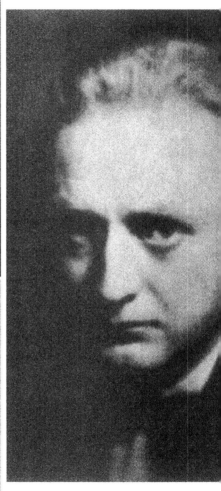

Laurence Vai

Yves Tanguy

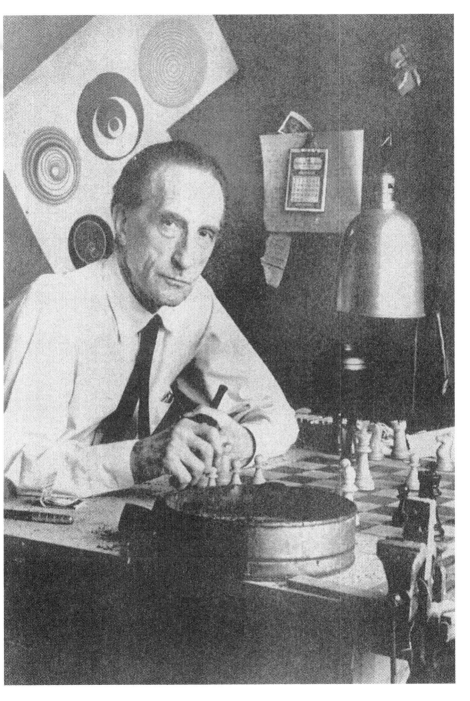

Marcel Duchamp

Art of This Century

for him and boiled them. I also learned which of my acquaintances had false teeth.

Presently I left this job and offered my services to my cousin, Harold Loeb. He had a little radical bookshop near Grand Central Station. I became a clerk and spent my afternoons on the balcony writing out checks and doing various boring jobs. I was only permitted downstairs at noon, when I had to replace the people who went to lunch, at which time I sold books. When I complained of my fate to Gilbert Cannan, who came often and sat for hours in the bookshop, he said to me, 'Never mind, Lady Hamilton started out as a kitchen-maid.'

Though I was only a clerk, I swept into the bookshop daily, highly perfumed, and wearing little pearls and a magnificent taupe coat. My mother disapproved of my working and came often to see what I was up to and to bring me rubbers if it was raining. This was embarrassing. My rich aunts also came and literally bought books by the yard to fill their bookcases. We had to bring out a tape measure to be sure the measurements coincided with their bookshelves.

In the bookshop I met many celebrities and writers and painters, among them my future husband, Laurence Vail, and Leon Fleischman and his wife Helen, who later married James Joyce's son. Laurence was about twenty-nine at this time, and to me he appeared like someone out of another world. He was the first man I knew who never wore a hat. His beautiful, streaky golden hair streamed all over as the wind caught it. I was shocked by his freedom, but fascinated at the same time. He had lived all his life in France and he had a French accent and rolled his r's. He was like a wild creature. He never

seemed to care what people thought. I felt when I walked down the street with him that he might suddenly fly away—he had so little connection with ordinary behaviour.

The Fleischmans became my great friends. They practically adopted me. One day Leon took me to see Alfred Stieglitz, one of the earliest promoters of modern art in the United States. They put the first abstract painting I had ever seen into my hands. It was painted by Georgia O'Keefe. I turned it around four times before I decided which way to look at it. They were delighted.

Soon after, I went to Europe. I didn't realize at the time that I was going to remain there for twenty-one years, but that wouldn't have stopped me. In those days my desire for seeing everything was very much in contrast to my lack of feeling for anything. That was born, however, as a result of my curiosity. I soon knew where every painting in Europe could be found, and I managed to get there, even if I had to spend hours going to a little country town to see only one. I had as a great friend Armand Lowengard, the nephew of Sir Joseph (later Lord) Duveen. He was a fanatic about Italian painting. Seeing what a good subject I was, he egged me on to study art. He told me that I would never be able to understand Berenson's criticism. This remark served its purpose. I immediately bought and digested seven volumes of that great critic. After that I was forever going around looking for Berenson's seven points. If I could find a painting with tactile value I was thrilled. Armand had been wounded in the war and was rather badly done in. My vitality nearly killed him and though he was fascinated by me, in the end he had to renounce me, as I was entirely too much for him.

I didn't see the Fleischmans again until I returned to America for a brief visit in the spring. I then persuaded the Fleischmans to come and live in Paris. As they had a child and little money, it was all very complicated. But they came. It changed their life as much as they had changed, and were still to change, mine.

Through the Fleischmans I again met Laurence Vail. A few days later he took me out for a walk. We went to the tomb of the Unknown Soldier and then we walked along the Seine. I was wearing an elegant costume trimmed with kolinsky fur, that I had designed for myself. He took me into a bistro and asked me what I wanted. I asked for a porto flip, thinking I was in the kind of bar I was used to. In those days I led only the most expensive sort of life and had never set foot in an ordinary café and had no idea what to order.

Laurence lived with his mother and his sister Clotilde in a very *bourgeois* apartment near the Bois. When his father was not in a sanatorium having a *crise de nerfs*, he was living at home upsetting his entire family. Laurence's mother was an aristocratic New England lady. His father was a painter of Breton ancestry, half French, half American. He had been neurasthenic for years and his family had no idea what to do about him. They had tried everything, but he was the world's great incurable neurotic.

Laurence wanted to get away from home. His mother gave him a small allowance of one hundred dollars a month and, considering her income was ten thousand dollars a year, she wasn't over-generous. But she preferred to spend it on her husband, whose capital had long

since vanished paying doctor's bills. He had been in every sanatorium in Europe. Laurence might have taken a job, but he didn't like working. He was a writer of considerable talent, but as yet unknown.

He now told me he was about to take a little apartment, and as at this time I was worried about my virginity—I was twenty-three and I found it burdensome—I asked if I could pay half the rent and share it, hoping by this manœuvre to get somewhere. He said yes, but soon changed his mind. The next time I saw him he told me he had taken a hotel room in the rue de Verneuil on the left bank in the Latin Quarter. He came to see me at the Plaza-Athénée Hotel, where I was living, and started to make love to me. When he pulled me towards him I acquiesced so quickly that he was surprised by my lack of resistance. However, I told him that we could not do anything there as my mother might return at any moment. He said we would go to his hotel room sometime. I immediately rushed to put on my hat and he took me to the rue de Verneuil. I am sure he had not meant to. That was how I lost my virginity. It was as simple as that.

MARRIAGES

MARRIAGES

Laurence was considered the King of Bohemia. He knew all the American writers and painters and a lot of French ones too. In those days they met at the Café de la Rotonde in Montparnasse. But Laurence had a row with a waiter or the manager of that café and he made everybody move opposite to the Dôme. For years they never returned to the Rotonde.

Laurence gave wonderful parties in his mother's apartment. The first one I went to was very wild. I took with me a *bourgeois* French playwright, and in order to make him feel at home in the midst of Bohemia, I sat on his lap most of the evening. Later I received a proposal (I can hardly say of marriage) from a girl who got down on her knees in front of me. Strange things were happening everywhere. Laurence's father was at home and was very annoyed by the confusion the party caused. In desperation he retired to the toilet, where he found two delicate young men weeping. He retired to the bathroom where he disturbed two giggling girls.

One day Laurence took me to the top of the Eiffel Tower and when we were gazing at Paris he asked me if I would like to marry him. I said 'Yes' at once. I thought it was a fine idea. As soon as he had asked me, he regretted it. In fact, from then on he kept changing his mind. Every time I saw him look as though he were trying to swallow his Adam's apple I knew he was

39

regretting his proposal. He got more and more nervous about our future and one day he ran away to Rouen to think matters over. But soon he wired that he still wanted to marry me.

After the banns were posted I began to think we might really marry, but suddenly Laurence decided to go to Capri and postpone the wedding. I was to return to New York, where he would join me in May if we still felt like marrying. One afternoon, when he was all packed, he went to buy the tickets for his trip. His mother, my mother and I sat in the Plaza-Athénée, each with her private feelings about the future. Suddenly Laurence appeared in the doorway, looking as pale as a ghost and said, 'Peggy, will you marry me?' Of course I said, 'Yes'. After that I was still not at all sure that Laurence would not run away, so I decided not to buy a dress for the wedding. I bought a hat instead.

The morning of the wedding Laurence's mother phoned me to say, 'He's off.' I thought she meant Laurence had run away again. He hadn't. She merely meant that he was on his way to fetch me. We went in a tramcar to the Mairie of the Seizième Arrondissement at Avenue Henri-Martin, where the ceremony was to take place.

We had all invited lots of friends. There were four distinct elements among the guests. First of all, Laurence had invited all his Bohemian friends, but as he was rather ashamed of marrying me, he had written them *petit bleu* notes briefly asking them to be present, as though he were asking them to a party, and he did not even mention who the bride was to be. My mother invited all her French Seligman cousins who lived in Paris, and all her *bourgeois* friends. Laurence's mother

invited the American colony, of which she herself was a well-known hostess. I invited all my friends. They were very mixed at that time. They were writers and painters, mostly from a very respectable milieu, and there was Boris, a Russian friend of mine, who came to the wedding and wept because I wasn't marrying him. Helen Fleischman was my witness and Laurence's sister was his. After the ceremony my mother gave us a big party at the Plaza- Athénée.

As soon as I found myself married, I felt extremely let down. Then, for the first time, I had a moment to think about whether or not I really desired the marriage. Up to the last minute Laurence had been in such a state of uncertainty that I had been kept in suspense and never questioned my own feelings. Now that I had achieved what I thought so desirable, I no longer valued it so much.

This marriage to Laurence Vail, which was extremely stormy, in fact, often much too much so, lasted for seven years. It brought me into the intellectual world of the 'twenties, which was terribly exciting. It also liberated me completely from my early Jewish *bourgeois* upbringing. The only permanent things I got out of it were my two children, Sinbad and Pegeen, and a life-long friendship with Laurence. But then I have always found husbands much more satisfactory after marriage than during.

My second husband, to whom I was never legally married, was John Holms, of whom Edwin Muir said: 'Holms gave me a greater feeling of genius than any other man I have met, and I think he must have been

one of the most remarkable men of his time, or indeed of any time.'

John opened up a whole new world of the senses to me, a world I had never dreamed of. He loved me because to him I was a real woman. At first I refused to listen to him talk, and he was delighted that I loved him as a man.

Although in the beginning I refused to listen to him talk and fell asleep at night while he was holding forth to me, little by little I opened my ears, and gradually, during the five years that I lived with him, I began to learn everything I know today, with the exception of what I have learnt about modern art. When I first met him I was like a baby in kindergarten, but by degrees he taught me everything and sowed the seeds in me that sprouted after he was no longer there to guide me.

I am sure that during the first two years of our life I was purely interested in making love, but when that lost its intensity I began to concentrate on all the other things that John could give me. I could pick at leisure from this great store of wealth. It never occurred to me that it would suddenly come to an end. He held me in the palm of his hand and from the time I once belonged to him to the day he died he directed my every move, my every thought. He always told me that people never got what they expected from a relationship. I certainly never dreamed of what I was to get from him. In fact, I never knew that anyone like John existed in the world. I don't know what he expected from me, but I don't think he was disappointed. His chief desire was to re-mould me, and he felt in me the possibilities that he was later to achieve, although he admitted that he got many other things he did not expect.

John not only loved women: he understood them. He knew what they felt. He always said, 'Poor women', as though he meant they deserved extra pity for being born of the wrong sex. He was so conscious of everybody's thoughts that it was painful for him to be in a room with discordant elements. Therefore he was supremely careful whom he chose to invite together. He had a wonderful gift of bringing out people's best qualities. He spent most of his time reading, and his criticism was of a quality that I had never before encountered. He was a great help to his writer friends, who accepted his opinions and criticisms without reserve. He never took anything for granted. He saw the underlying meanings of everything. He knew why everybody wrote as they did, made the kind of films they made or painted the kind of pictures they painted. To be in his company was equivalent to living in a sort of undreamed of fifth dimension. It had never occurred to me that the things he thought about existed. He was the only person I have ever met who could give me a satisfactory reply to any question. He never said, 'I don't know.' He always did know. Since no one else shared his extraordinary mental capacity, he was exceedingly bored when talking to most people. As a result, he was very lonely. He knew what gifts he had and felt wicked for not using them. Not being able to write, he was unhappy, which caused him to drink more and more. All the time that I was with him I was shocked by his paralysis of will power. It seemed to grow steadily, and in the end he could hardly force himself to do the simplest things.

All this ended in 1934, when John died under an anaesthetic for a very minor operation on a broken wrist. When the doctors told me he was dead it was as

though I was suddenly released from a prison. I had been John's slave for five years and I imagined for a moment I wanted to be free, but I didn't at all. I was absolutely bankrupt. In desperation I went to live with a friend of John's with whom I had been physically and secretly in love for a year, but whom I had ceased to see because I was afraid of ruining my relationship with John. This union, which was not a legal one, but from which I acquired a lovely step-daughter, Debbie, whom I brought up with Pegeen, was completely ruined by the fact that I had never recovered from John's influence. This 'marriage' ended after three years, as my husband became a communist.

GUGGENHEIM JEUNE

GUGGENHEIM JEUNE

Feeling bored and lonely, living in the country in England by myself, I began to think of ways of occupying myself and of being useful, if possible. My friend, Peggy Waldman, suggested I should go into publishing, but fearing that would be too expensive, I accepted her other alternative, to open a modern art gallery. Little did I dream of the thousands of dollars I was about to sink into art. My mother had just died and left me about as much as I had inherited from my father, but this was also in trust, alas.

At this point of my existence I was practically ignorant of all art after the Impressionists. So when I started my new project I needed much help and advice, which I got from an old friend, Marcel Duchamp, the forerunner of Surrealism, as Sir Herbert Read has described him, whom I had known for fifteen years. I don't know what I would have done without him. He had to educate me completely. I could not distinguish one modern work of art from another, but he taught me the difference between Surrealism, Cubism and abstract art. Then he introduced me to all the artists. They all adored him and I was well received wherever I went. He planned shows for me and gave me all his best advice. I have to thank him for my introduction to the modern art world.

I wanted to dedicate the first show of Guggenheim

Jeune (the name given to my gallery by Wyn Henderson, my secretary) to the work of Brancusi, the only modern artist I knew. In fact, I had known him for sixteen years. But he was not in Paris, so Marcel Duchamp decided that we should invite Cocteau to exhibit instead.

The arrangements for the Cocteau show were rather difficult. First of all I had to tear myself away from Samuel Beckett, with whom I was terribly in love. To speak to Cocteau one had to go to his hotel in the rue de Cambon and try to talk to him while he lay in bed, smoking opium. The odour was extremely pleasant, though this seemed a rather odd way of doing our business. One night he decided to invite me to dinner. He sat opposite a mirror, which was behind me, and so fascinated was he by himself that he could not keep his eyes off it. He was so beautiful. with his long oriental face and his exquisite hands and tapering fingers, that I do not blame him for the delight he took in his image.

His conversation was as fascinating as his face and hands, and I longed for him to come to London for the show, but he was not well enough. However, he wrote the introduction for his catalogue and Samuel Beckett translated it.

Cocteau sent me about thirty original drawings he had made for the décor of his play, *Les Chevaliers de la Table Ronde*. He also made some drawings in ink in the same spirit as the others, and two on linen bed sheets that were specially done for the show. One was an allegorical subject called 'La Peur donnant ailes au Courage', which included a portrait of the actor, Jean Marais. He and two very decadent looking figures appeared with pubic hairs. Cocteau had pinned leaves over these, but the drawing caused a great scandal with

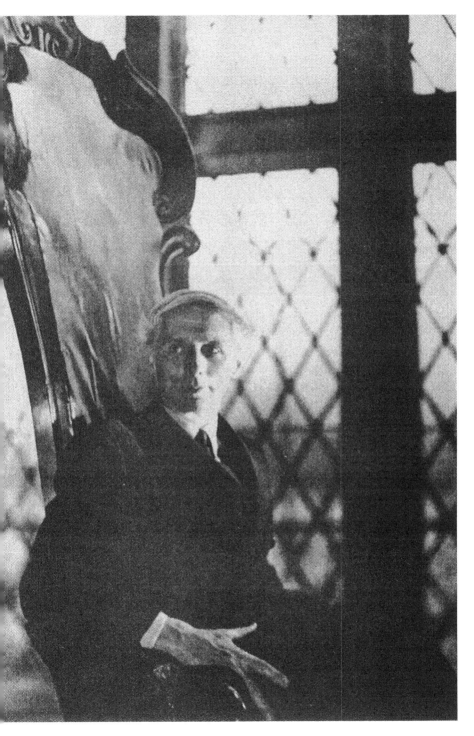

Max Ernst

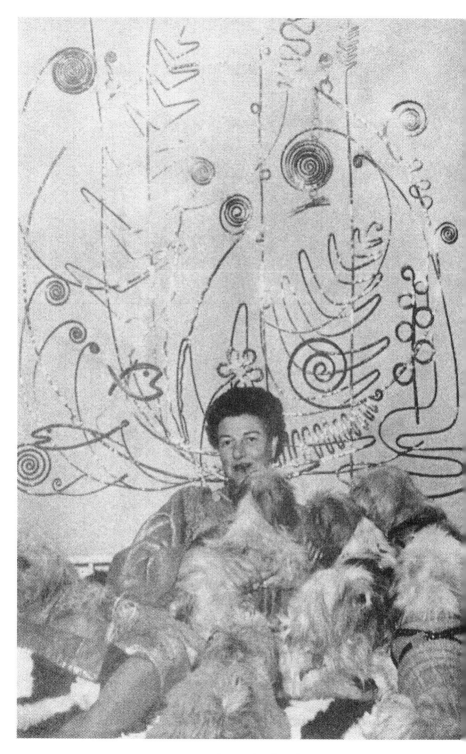

Calder's bedhead

the British Customs, who would not release it. I asked why they objected to the nude in art, and they replied it was not the nude but the pubic hairs which worried them. Finally, they allowed me to take the linen sheet away, on condition that I promised not to exhibit it in public, so I hung it in my private office at Guggenheim Jeune. In fact, I liked it so much that in the end I bought it.

This was before I was thinking of collecting. But gradually I bought one work of art from every show I gave, so as not to disappoint the artists if I were unsuccessful in selling anything. In those days, as I had no idea how to sell and had never bought pictures, this seemed to be the best solution and the least I could do to please the artists.

In spite of the fact that I had opened this gallery, I still much preferred old masters to modern art. Beckett told me that one had to accept the art of one's day, as it was a living thing. He adored the paintings of Jack Yeats and of Geer van Velde, and he wanted me to give them both exhibitions. I could not refuse him anything, so it was agreed. Jack Yeats luckily realized that his painting was not at all in line with my gallery and let me off. But I agreed and gave the Van Velde show. In fact, I bought some of the pictures which were rather like Picasso's, secretly under various names in order to please Beckett, but even after this Van Velde, not knowing I had done so, asked me for five hundred dollars, which I could not refuse him.

Beckett lived in Paris, and because of the gallery I was supposed to live in London. But because of Beckett I was

always leaving the gallery to Wyn Henderson and rushing off to Paris to be with him. He could not make up his mind either to have me or to let me go. Ever since his birth, he had retained a terrible memory of life in his mother's womb. He was constantly suffering from this and had awful crises, when he felt he was suffocating. He always said our life would be all right one day, but if I ever pressed him to make any decision it was fatal and he took back everything he had previously said. At this time his book *Murphy* came out, and he gave it to me, as well as his previous study on Proust, which was excellent.

Though I adored talking to him and being with him, conversing with him was very difficult. He was never very animated and it took hours and lots of drink to warm him up before he finally unravelled himself. He was a very fascinating lanky Irishman with green eyes and a thin face and a nose like an eagle and his clothes were very French and tight-fitting. He was extremely intellectual and abstract as a person and had an enormous passion for James Joyce, and had once been engaged to his daughter.

Beckett was not Joyce's secretary, as everyone has since claimed, though he was perpetually doing errands for him. Joyce had a Russian Jewish intellectual for secretary, called Paul Leon, who was later killed by the Germans.

In 1938, Joyce had his fifty-second birthday, for which occasion Maria Jolas, a great friend of the Joyces, gave him a dinner party. Beckett was in a state of great excitement about suitable gifts. He went with me and made me buy a blackthorn stick. As for his own present, he wished to give Joyce some Swiss wine, Joyce's

favourite beverage. I remembered years before that John Holms and I had dined with Joyce in a Swiss restaurant on the Rue Ste Anne, so I went back there and asked the proprietor if he would sell us some. Of course, he was delighted to do so.

The party was a great success, and Joyce wore a beautiful Irish waistcoat which had belonged to his grandfather. This was the *Finnegans Wake* period and Joyce offered a hundred francs to anyone who could guess under what name it would be published. I think Beckett was the winner. The table was decorated with a plaster model of Dublin, through which ran a green ribbon representing the River Liffey. Joyce was very happy, surrounded by all his adorers, and after quite a lot to drink, got up and did a little jig by himself in the middle of the floor.

In Paris Marcel presented me to Jean Arp, the sculptor who was an excellent poet and most amusing man. He took me to Meudon to see the modern house he had built for himself and Sophie, his wife. They had separate studios, each consisting of a whole floor, and there was a garden full of Arp's sculpture. Sophie, a Swiss ex-school mistress, was an abstract painter and sculptress. Arp's work was more Surrealist, but he managed to keep on both sides of the fence and exhibited with both groups. Sophie edited an interesting art review called *Plastique*. Arp was always trying to further Sophie's career, and since her work was rather dull it often became painful to be so bored about nothing. They had done one sculpture together called 'Sculpture Conjugal'. Sophie was a wonderful wife, she did everything possible

for Arp, besides doing her own work and running the magazine. The very first sculpture I ever bought was an Arp bronze. He took me to the foundry where it had been cast, and I fell so in love with it that I asked to take it in my hands. The instant I felt it, I wanted to own it. Marcel also sent me to see Kandinsky. He was a wonderful old man of seventy, so jolly and charming, with a wife some thirty years younger, called Nina. I asked him if he wanted to have an exhibition in London and as he had never shown in England, though Sir Michael Sadler, who was a friend of his, owned a lot of his pictures, he was delighted. Kandinsky was very upset because my uncle Solomon Guggenheim had ceased to buy his paintings and instead bought paintings by an imitator of his, Rudolph Bauer. Kandinsky claimed that though he had encouraged my uncle to buy Bauer, Bauer never encouraged my uncle to buy Kandinsky. He now begged me to try to get him to buy one of his early works which my uncle wanted, and I promised to do so.

Kandinsky asked for a plan of my gallery and when he received it, decided where the pictures should be placed. The show included paintings from 1910 to 1937. Kandinsky was very business-like and resembled a Wall Street broker. How I wish I had bought all the pictures in the show. I only bought one late one and none of the marvellous early ones. These I eventually had to find years later in New York.

What a joy those three weeks were! One day during the exhibition an art teacher from a public school in the north of England came to the gallery and begged me to allow him to show ten Kandinsky paintings to his pupils at his school. I was delighted with the idea and wrote

to Kandinsky for his permission. He was equally pleased with the idea, but insisted that the pictures be insured. When my show was over, the schoolmaster came and strapped ten canvasses on to the top of his car and drove away with them. When he brought them back he told me how much they had meant to his school.

As I had promised Kandinsky, I wrote to my uncle Solomon asking him if he still wished to buy the painting that he had previously wanted. I received a friendly letter from him in reply, saying that he had turned the letter over to the Baroness Rebay, the curator of his Museum, and that she would reply herself, which she did in due time, saying:

Dear Mrs Guggenheim Jeune,
 Your request to sell us a Kandinsky picture was given to me to answer.
 First of all we do not ever buy from any dealer as long as great artists offer their work for sale themselves, and secondly will be your gallery the last one for our Foundation to use, if ever the need to get historically important pictures should force us to use a sales gallery.
 It is extremely distasteful at this moment, when the name of Guggenheim stands for an ideal in art, to see it used for commerce so as to give the wrong impression, as if this great philanthropic work was intended to be a useful boost to some small shop.
 Non-objective art, you will soon find out, does not come by the dozen, to make a shop of this art profitable. Commerce with real art cannot exist, for this reason. You will soon find out you are propagating mediocrity, if not trash. If you are interested in non-

objective art you can well afford to buy it and start a collection. This way you can get into useful contact with artists, and you can leave a fine collection to your country if you know how to choose. If you don't you will soon find yourself in trouble also in commerce.

Due to the foresight of an important man since many years collecting and protecting real art through my work and experience, the name of Guggenheim became known for great art and it is very poor taste indeed to make use of it, of our work and fame, to cheapen it to a profit.

<div align="right">Yours very truly
H.R.</div>

P.S. Now our newest publication will not be sent to England for some time to come.

I soon got into trouble again with the British Customs. Marcel Duchamp had sent me from Paris a sculpture show, consisting of works by Brancusi, Raymond Duchamp-Villon, Antoine Pevsner, Arp, his wife, Henri Laurens and Alexander Calder. Henry Moore was to represent England. But the Customs would not admit the show into England as an art exhibition. It could only be allowed in if the exhibits were admitted as separate pieces of bronze, marble, wood, etc., which would have meant my having to pay heavy duty on them, which I would have done had it come to the worst. This was because of a stupid old law which existed to protect English stone-cutters from foreign competition. It rested with the Director of the Tate Gallery to decide in such cases what was art and

what was not. Mr Manson, the Director, refused to pass my show, which he declared was not art. This was really so scandalous that Wyn Henderson got all the art critics to sign a protest against this verdict. As a result, my case was brought up in the House of Commons and we won it.

From then on, any sculpture, whether abstract or not, could be admitted into England without the approval of the Director of the Tate Gallery. I thus rendered a great service to foreign artists and to England. The press took up the story and the show had marvellous publicity and was a great success.

Wyn Henderson, who had organized all this, was a remarkable woman, a sort of fat Titian-beauty type. She made everything go like clockwork in the gallery, though she had no previous experience of anything of this kind, being a typographer by profession. She had run several modern presses, and therefore we had the most beautiful catalogues and invitations. She had a lot of common sense, tact and social grace, remembering the faces of all the people who came to the gallery, whom I never recognized.

Henry Moore, a very direct simple Yorkshireman of forty years, who was then teaching art to earn his living, was having a great success in London at the time of the sculpture show. He lent us a very large wooden reclining figure, which looked beautiful in the centre of the gallery. I would have liked to have bought it, but it was much too large for my house. I said that had it been smaller it would have pleased me very much. One day, months later, he arrived in the gallery like a travelling salesman, carrying a little handbag. From this he brought out two elegant reclining figures,

one in bronze and one in lead, and asked me to choose one. I infinitely preferred the bronze, which I acquired. One day a marvellous man in a highly elaborate tweed coat walked into the gallery. He looked like Groucho Marx. He was as animated as a jazz-band leader; which he turned out to be. He showed us his gouaches, which were as musical as Kandinsky's, as delicate as Klee's, and as gay as Miró's. His colour was exquisite and his construction magnificent. His name was John Tunnard. He asked me very modestly if I thought I could give him a show, and then and there I fixed a date. (Later, he told me he couldn't believe his good luck, he was so used to being turned down.) During this exhibition, which was a great success from every point of view, a woman came into the gallery and asked, 'Who is this John Tunnard?' Turning three somersaults, Tunnard, who was in the gallery, landed at this lady's feet, saying, 'I am John Tunnard.' At the end of the show I, amongst many others, bought an oil painting with the extraordinary title 'P s ɪ' in green letters. Alfred H. Barr, director of the Museum of Modern Art in New York, admired it so much when he saw it years later that he wanted to buy it for the Museum, but I would not part with it, and he had to find another one instead.

Another day Piet Mondrian, the famous Dutch abstract painter, walked into Guggenheim Jeune, and instead of talking about art, asked me if I could recommend a night club. As he was sixty-six years old, I was rather surprised, but when I danced with him I realized how he could still enjoy himself so much. He was a very fine dancer, with his military bearing, and was full of life and spirits, though it was impossible to talk to him in

any language. Possibly his own, Dutch, would have been more satisfactory than his very odd French and English, but I somehow doubted that he even spoke his own native tongue.

The second year of Guggenheim Jeune we gave a beautiful show of Yves Tanguy's paintings. He was a simple man from Brittany, about thirty years old, and had been in the *Marine Marchande* for years. His father had once had a position in one of the Ministries, and Tanguy as a result was born in a building on the Place de la Concorde. This rather official commencement to his life did not make him at all pompous. On the contrary, he was completely unpretentious. In 1926, he went to André Breton, the poet, writer and leader of the Surrealists and started painting for the first time in his life. Of course, under Breton's influence he painted what Breton considered Surrealist paintings, but I always considered them much more abstract. He adored Breton the way Beckett adored Joyce, and was always disappearing in order to do odd errands for him. Tanguy had been mad at one time and was therefore exempted from the French army. He had a lovely personality, was modest and shy and as adorable as a child. He had little hair (what he had stood straight up from his head when he was drunk, which unfortunately was very often), and beautiful little feet, of which he was extremely proud. He was very fond of me and once told me I could have had anything in the world I wanted from him; but I was still in love with Beckett at the time.

His show had a great success and we sold a lot of paintings, as Surrealism was beginning to become known in England at this time. As a result, Tanguy suddenly found himself rich for the first time in his life

and began to throw money around like mad. In cafés he used to make little balls of one pound notes and flicker them about to adjacent tables. Sometimes he even burnt them. He had a great friend in Paris, a painter called Victor Brauner, a Roumanian, who was looking after Tanguy's Manx cat while Tanguy was in London. Every day Tanguy sent a pound note to the cat, but in reality it was meant for Brauner, who was very poor.

Tanguy came to visit me in my country house in Sussex and did lovely drawings. One of them so much resembled me that I made him give it to me. It had a little feather in place of a tail, and eyes that looked like the china eyes of a doll when its head is broken and you can see inside. He also did a little phallic design for my Dunhill lighter, which we had engraved, and last but not least, he painted me two miniature paintings on earrings which were, according to Herbert Read, the most beautiful Tanguy paintings in the world. I also bought several of the paintings from his show for myself and gave some of his gouaches as presents. Tanguy's gouaches were exquisite and he sold a great many of them, as well as some oils but soon he had no money left, as he had thrown it all away. He told me it was too bad that I had given it all to him at once and that I should have doled it out to him instead.

My ex-husband, Laurence Vail, and my children, all wanted me to marry Tanguy, but I felt I needed a father, not a son.

During one of my visits to Paris, which were still frequent (because of Beckett and Tanguy), Tanguy disappeared for forty-eight hours, and as neither he nor I had a phone, it was impossible to reach him. Finally he came back and told me what had occurred. There had

been a row at a Surrealist party and it had ended up with poor Brauner losing an eye. He had had nothing to do with the row, in fact, he was an innocent onlooker who had tried to separate the belligerents. Dominguez, a Surrealist painter, an awful brute of a man, had seized a bottle and hurled it at someone else and it had broken and rebounded in Brauner's eye, which fell out. Tanguy took him to the hospital, where an operation was performed to replace his eye and remove the pieces of glass.

We were all very upset about Brauner's accident. Later the poor thing had to have a second operation on his eye, as the doctor had not removed all the glass. After that we bought him a glass eye. He had enormous pride and courage and, once he was readjusted to life, began to paint very well. I went to see him with Tanguy and bought one of his paintings. He showed me a self-portrait he had done the year before, with one eye falling out of its socket. He seemed to have prophesied this catastrophe, and after it occurred his paintings made great progress, as though he had been freed from some impending evil.

If Brauner had a mystic sense, I also proved to have one. Tanguy had taken me to a book shop where he wished to find a volume called *Huon de Bordeaux* by Gaston Paris, illustrated by Orazi. This was a book Tanguy had received as a prize in his school days. I paid little attention to what he was doing in the shop; in fact, I didn't even know what he was searching for. I went next door to look at a Larousse dictionary which I wanted to give him. When I came back, I walked absent-mindedly up to the bookshelves and the first book I pulled out was the one Tanguy had been un-

successfully seeking for half an hour. I think this pleased him more than anything else I ever did for him.

At this time there was a terrible feud among the Surrealists, and they were split into two camps. Paul Eluard had taken away half or more of Breton's followers. They were both too strong to be leaders of the same party, and as one or other had to give in, but neither would do so, the party split into two. Breton must have given orders to his disciples not to speak to any of the rebels, because Tanguy would not permit himself to remain in the same room with any of the other faction. The whole thing was ridiculous and Tanguy would not go anywhere with me, he was so afraid of meeting the rebels.

André Breton was a handsome man of about forty, with a head like a lion and a big shock of hair. He had a kingly appearance, but his manners were so formal and so perfect that it was difficult to get used to being treated so courteously. He was very pompous, with no sense of humour. He had a blonde, artificial looking Surrealist wife called Jacqueline who was also a painter (she had formerly been an underwater dancer) and a child called Aube. They both followed him everywhere and the child was a pest in cafés. Tanguy adored the whole Breton family.

Breton himself seemed more like an actor or a preacher than a poet. He was a marvellous talker and used to sit in a café surrounded by his disciples, sometimes as many as forty of them. When the war was declared it was strange to see him in the uniform of a military doctor (in the First World War he had served in the army as a psychiatrist) and he went around with medical books in his pockets.

60

I finally got over my passion for Beckett. I remember saying to him one day, 'Oh dear, I forgot that I was no longer in love with you.' I think it was the result of having consulted a fortune teller. She seemed to think it was the moment to marry him or give him up. She said he was an awful autocrat. When I told this to Beckett, he said, 'Have you decided not to marry me?' I was relieved to feel able to say, 'Yes.' After eighteen months of frustration it was high time.

In 1939, after a year and a half of Guggenheim Jeune, it seemed stupid to lose so much money for nothing, and I decided to open a museum of modern art instead. The gallery was suffering a loss of about six thousand dollars a year, although it appeared to be successful. I felt that if I were losing that much money, I might as well spend a lot more and do something worthwhile. So I approached Herbert (now Sir Herbert) Read, whom I knew through his often coming to the gallery, and who was trying very hard to promote modern art in England. I liked him and felt we could work well together. I persuaded him to give up his position as editor of the stuffy *Burlington Magazine*, and in exchange gave him a five year contract as director of the new museum, which was to open in the autumn. Wyn Henderson chose the title of 'registrar' for herself. God knows what my position was to be. Herbert Read offered to help me for six months without any salary until we could get started, my arrangement with him having made it possible for him to buy a partnership in Routledge's publishing firm.

I did not have nearly enough money for this venture,

as I had commitments of about ten thousand dollars a year to various friends and artists whom I had been supporting for years. I could not suddenly let them down for the museum, much as I wanted to. I tried to think of ways to cut down my own personal expenses. In fact, I decided to live a monastic life in order to be able to produce the necessary funds. I intended not to buy any more clothes, and sold my Delage car and bought a little Talbot instead. As we had no money to buy paintings, we decided to borrow them, or to try to get people to give them to us. I went to my aunt, Mrs Solomon Guggenheim, and asked her if she thought I could get my uncle to give me something, but all she said was that the Baroness Rebay would have to be consulted, and then maybe I would get a Bauer (the very last thing in the world I wanted). Herbert Read did better. He got lots of promises from people to lend pictures, even to give them.

Herbert Read was a very distinguished looking man. He resembled a prime minister and seemed to be very well bred, though he boasted of being the son of a Yorkshire farmer. He had grey hair and blue eyes and was reserved, dignified and quiet. He was very learned and the author of many books on art and literature, a lot of which I had in my library, though I never read half of them, as they were too difficult for me. He soon became a sort of father in my life, and behind his back I called him 'Papa'. He treated me very much in the same fashion as I imagine Disraeli treated Queen Victoria. I think I must have been rather in love with him, spiritually. We planned a wonderful future for ourselves. How innocent we were! But then I suppose some of the best things in the world are the ones that never come off.

We intended to go to New York after our museum opened, in order to raise money and to study the workings of the Museum of Modern Art.

At the beginning, Herbert Read had been a little nervous about staking his future on me. He wanted some kind of a reference, and as I could not give him one, he went to T. S. Eliot, his best friend, and asked him what to do. Mr Eliot, whom I had never met, reassured him by saying, 'I have never heard Mrs Guggenheim spoken of in any but the highest terms.' That must have settled it for Herbert Read. He could hardly believe his good fortune. He must have thought that I had fallen from heaven. He had previously been at the Victoria and Albert Museum, but all his life he had dreamt of making an ideal modern museum, and he showed me an article he had written on the subject.

His first idea was to dedicate our opening show to the whole field of art that we were to cover. The paintings were to have been borrowed from Paris. He made a list (which was later revised by Marcel Duchamp and Nellie van Doesburg and myself, because it had so many mistakes) which became the basis of my present collection.

Herbert Read wanted the museum to start with the first abstract and Cubist paintings from 1910, but every now and then he would lapse into Cézanne, Matisse and Rousseau and other painters whom I thought we should omit as they did not fit in.

We spent weeks trying to find a suitable place to house the new museum, but did not succeed until the summer, when one day Herbert phoned to tell me he had found the perfect place. It was Sir Kenneth Clark's house in Portland Place. Lady Clark took me through it.

It really was ideal for our purpose, even though it was Regency instead of being modern. Lady Clark, who had been a gym teacher, was particularly pleased with an air-raid shelter she had made in the basement. She told me she was going to live in the country to please her children. I was so naïve that I did not realize how fast the war was approaching and I thought I was very fortunate to get the house. The only trouble with it was that it was too large, so I conceived the idea of living on one of the upper floors. But to my dismay Mrs Read conceived the idea of living on another. We soon began to argue about which floor we would occupy.

In August, I went to Paris to find the pictures we were to borrow, but the war broke out and put an end to the argument and to the whole museum project, as we could not expose borrowed pictures to the London bombings, even though Herbert Read thought London was an ideal spot for the museum, in spite of the war. I felt morally obliged to give him half of his salary for five years, which I did at once, feeling rather pleased that at least I had got him out of the stuffy *Burlington Magazine* and into Routledge's.

My next project (which also never came to anything), was a scheme to form an artists' colony for the duration of the war, and to invite as guests all the artists who wanted to come. They would receive a small allowance and in return would have to give me paintings for the future museum. Nellie van Doesburg, my newest friend, was to be secretary of this colony. She was the widow of van Doesburg, of the de Stijl movement, and I called her the 'de Stijl baby'. She was much younger than van Doesburg. She was also terrifically energetic. young in spirit and knew a great deal about art and was

friendly with all the artists. She later was a great help to me in forming my collection and taught me a lot. Her passion was abstract art, about which she was quite fanatical.

Soon after the war began, Nellie and I began driving all over the South of France to look for suitable accommodation for the colony. We looked at hotels, châteaux and houses. This gave me a pleasant excuse for travelling, and as I really believed in the project, it became a sort of mission. Had I known more about artists at that time, I never would have dreamt of anything so mad as trying to live with them in any kind of harmony or peace. Nellie really should have known better. As soon as I got back once more to Paris and met a few of the people we had thought of inviting, I realized what a hell life would have been. They not only did not wish to live together, but even refused to dine with each other. There were so many petty feuds and jealousies it was unbelievable. So I had to relinquish the project.

SERIOUS COLLECTING

SERIOUS COLLECTING

I decided now to buy paintings by all the painters who were on Herbert Read's list. Having plenty of time, and all the museum funds at my disposal, I put myself on a regime to buy a picture a day. With the help of Nellie and Howard Putzel I set to work. Putzel first became known to me in the winter of 1938, when he wrote me from Hollywood, where he had a gallery, to wish me good luck upon the opening of mine and to announce the closing of his. At that time he sent me some Tanguy paintings that he had exhibited out there and that were to be included in my Tanguy show. I met him a few months later in Paris and was surprised to find him exactly the opposite, physically, to what I had imagined he would be. I had expected to meet a little black hunchback. Instead of this, he turned out to be a big fat blond of my own age.

At first he was nearly incoherent, but little by little I realized the great passion for modern art and classical music that lurked behind his incomprehensible conversation and behaviour. He immediately took me in hand and escorted me, or rather forced me to accompany him, to all the artists' studios in Paris. He also made me buy innumerable things that I didn't want, but he found me many paintings that I did need, and usually ones of the highest quality. He used to arrive in the morning with several things under his arm for my

approval, and was hurt when I did not buy them. If I found or bought paintings 'behind his back', as he must surely have considered any independent action on my part, he was even more offended.

He and Nellie disliked each other as only rivals of extreme passion can. Of course, everyone in Paris knew that I was in the market, and, I suppose because of the war, were more than ever anxious to sell paintings. I was chased unmercifully. My phone rang all day, and people even brought paintings to my bedside in the morning before I rose.

I found three wonderful paintings by Max Ernst at a dealer's on the Left Bank, and bought them at once. One of these was 'The Kiss', a painting that was later exhibited in the Museum of Modern Art as a twentieth-century masterpiece. The year before, Putzel had taken me to Ernst's studio to buy a painting, but there had been no sale at that time. Ernst had a terrific reputation for his beauty, his charm and his success with women, besides being so well known for his Surrealist paintings and *collages*. He was very good looking, though nearly fifty. He had white hair and big blue eyes and a handsome beak-like nose resembling a bird's. He was exquisitely made. He talked very little, so I was forced to carry on a continuous chatter. At the feet of Ernst sat his beautiful lady love and pupil, Leonora Carrington. They looked like Nell and her grandfather in *The Old Curiosity Shop*.

I tried to buy a painting of Ernst's, but the one I wanted belonged to Leonora, and another one, for some unknown reason, was declared by Putzel to be too cheap. I ended up instead by buying one of Leonora's. She was unknown at that time, but full of imagination in

the best Surrealist manner and always painted animals and birds. This canvas, which was called 'The Horses of Lord Candlestick', portrayed four horses of four different colours in a tree. Everyone was delighted by this purchase. For years I had wanted to buy a Brancusi bronze, but had not been able to afford one. Now the moment seemed to have arrived for this great acquisition. I spent months becoming more and more involved with Brancusi before this sale was actually accomplished. I had known him for sixteen years, but never dreamed I was to get into such complications with him. It was very difficult to talk price to Brancusi, and if you ever had the courage to do so, you had to expect him to ask you some monstrous sum. I was aware of this, and hoped my excessive friendship with him would make things easier. But in spite of all this, we ended up in a terrible row when he asked me for four thousand dollars for the 'Bird in Space'.

Brancusi's studio was in a cul-de-sac. It was a huge workshop, filled with his enormous sculptures, and looked like a cemetery, except that the sculptures were much too big to be on graves. Next to this big room was a little one where he actually worked. The walls were covered with every conceivable instrument necessary for his work. In the centre was a furnace in which he heated his instruments and melted bronze. In this furnace he also cooked delicious meals, burning them on purpose, only to pretend that it had been an error. He ate at a counter and served lovely drinks, made very carefully. Between this little room and the big one, which was so cold that in winter it was quite unusable, there was a little recess where Brancusi played oriental music on a gramophone he had made himself. Upstairs

was his bedroom, a very modest affair. The whole place, including the bedroom, was covered in white dust from the sculptures.

Brancusi was a marvellous little man with a beard and piercing dark eyes. He was half an astute peasant and half a real god. It made you very happy to be with him, but unfortunately he got too possessive about me and wanted all of my time. He called me Pegitza and told me he liked going on long trips and formerly had taken beautiful girls with him. He now wanted to take me, but I would not go. He also liked to go to very elegant hotels in France and arrive dressed like a peasant, and then order the most expensive things possible. He had been to India to visit the Maharajah of Indore, in whose garden he had placed three 'Birds in Space', one in white marble, one in black and the third in bronze. He had also been back to Roumania, his own country, where the government had asked him to build public monuments. He was very proud of this. Most of his life had been very austerely led and devoted entirely to his work. He had sacrificed everything to this and had given up women for the most part, to the point of anguish. In his old age he was very lonely. He had a persecution complex and always thought people were spying on him. When he did not cook for me, he used to dress up and take me out to dinner. He loved me very much, but I never could get anything out of him. Laurence Vail suggested jokingly that I should marry Brancusi in order to inherit all his sculptures. I investigated the possibility, but soon discovered that he had other ideas and did not desire to have me as an heir. He would have preferred to sell me everything and then hide all the money in his wooden shoes.

After the row, I vanished from Brancusi's life for several months, during which time I bought a much earlier bird of his, called 'Maestro', for one thousand dollars, from Paul Poiret's sister. It was his first bird, dating from 1912. It was a beautiful bird with an enormous stomach, but I still hankered after the 'Bird in Space' which was so different. I asked Nellie, whom he called 'Nellitska', to go and try to patch up the row for me. I then went back to his studio and we began to discuss the sale all over again. This time we fixed the price in francs, and by buying them in New York I saved a thousand dollars on the exchange. Brancusi felt cheated, but accepted the money.

Brancusi polished all his sculptures by hand. I think that is why they are so beautiful. This 'Bird in Space' was to give him several week's work. By the time he had finished it the Germans were near Paris, and I went and fetched it in my little car to have it packed and shipped away in time. Tears were streaming down Brancusi's face. I was genuinely touched. I never knew why he was so upset, but assumed it was because he was parting with his favourite bird.

I wanted also to buy a sculpture of Giacometti's. One day I found a badly damaged plaster cast of his in an art gallery on the *rive gauche*. I went to see him and asked him if he would mend it for me, if I bought it, as I wanted it cast in bronze. He told me that he had a much better one in his studio. As it proved to be just as good, I bought this one. His studio was in a tiny street off the Avenue du Maine and was so small I don't see how he could have worked in it. He looked like an imprisoned lion, with his lionesque head and an enormous shock of hair. His conversation and behaviour were extremely

73

Surrealist and whimsical, like a divertimento of Mozart. After he had the bronze cast, he appeared one morning on my terrace with what resembled a strange medieval animal. Together they looked exactly like the Carpaccio painting of St George leading in the captive dragon from whom he has delivered the princess, which is in the Scuola San Giorgio degli Schiavoni, in Venice. Giacometti was extremely excited, which surprised me very much because I thought he had lost all interest in his earlier work, having long since renounced abstractions in order to carve little Greek heads, which he carried in his pocket. He had refused to exhibit in my sculpture show in London because I would not show one of these. He said all art was alike. I much preferred my bronze, which was called 'Woman with a Cut Throat'. It was the first of Giacometti's work ever to be cast, and when, years later, I returned to Europe after the war, to my great horror I seemed to see it everywhere, though I suppose the number of casts must have been limited to about six.

The day Hitler walked into Norway, I walked into Léger's studio and bought a wonderful 1919 painting from him for one thousand dollars. He never got over the fact that I should be buying paintings on such a day. Léger was a terrifically vital man, who looked like a butcher. During his stay in New York, where he finally got after the German occupation of France, he became a sort of guide and took us all to foreign restaurants in every quarter of the city. He seemed to know every inch of New York, which he had discovered on foot.

The phony war continued all winter, and I personally

was convinced that the Germans would never get to Paris. Therefore I tried to find a suitable place to house my fast-growing collection. I was living in a pent-house on the Ile de St Louis and could not hang any pictures there as it was all windows. I found a beautiful apartment on the Place Vendôme, where Chopin had died, as well as. the shop of the famous tailor O'Rossin. I found it on the same day that I went to see Léger, but the owner of the apartment did everything in his power to discourage me from taking it. He thought I was mad. He said, 'Think it over and come back to-morrow.' I went back the next day and told him I had not changed my mind, so he let me have it. I then got the architect, van Togerloo, to draw up plans to remodel this spacious place, where I intended to live as well as make a museum. It was over-decorated in the *fin de siècle* style. I insisted on having all the angels removed from the ceiling and scraped off the wedding-cake stucci from the walls. At this point, it obviously became impossible to continue with the scheme, as the Germans were nearing Paris. I asked the landlord to give me the cellars instead, to make a museum, but they had to be kept for air-raid shelters.

The only thing to do with the paintings was to pack them and get them out of Paris before it was too late or store them in an underground vault. Léger told me he thought the Louvre would give me one cubic metre of space somewhere in the country, where they were hiding their own treasures. So I had my pictures taken off their stretchers and packed into one cubic metre. To my dismay, the Louvre decided that my pictures were not worth saving and refused me the space. What they considered not worth saving were a Kandinsky, several

75

Klees and Picabias, a Cubist Braque, a Gris, a Léger, a Gleizes, a Marcoussis, a Delaunay, two Futurists, a Severini, and a Balla, a Doesburg, and a 'de Stijl' Mondrian. Among the Surrealist paintings were those of Miró, Max Ernst, de Chirico, Tanguy, Dali, Magritte and Brauner. The sculpture they had not even considered, though it comprised works by Brancusi, Lipchitz, Laurens, Pevsner, Giacometti, Moore, and Arp. Finally my friend, Maria Jolas, who had rented a château near Vichy to evacuate her bilingual school of children, said she would keep my collection in her barn. So I sent them there.

Nellie and I fled from Paris three days before the Germans entered. Two million people left the same day in cars, driving at one or two miles an hour, four abreast. It was a general exodus performed in a cloud of black smoke. Most of the cars went to Bordeaux, but we went south, where my children, Sinbad and Pegeen, were with their father. We were warned not to go in this direction, as Italy had just declared war on France, and we might meet the Italian army. On the way, we learned the dreadful news of the fall of Paris, and a few days later came the tragic armistice terms.

Finally I took a house for my children at Le Veyrier, on the lake of Annecy. For company I had Nellie and Jean Arp and his wife, who came to stay with us. They were worried about the future, as they could not go back to Meudon, in occupied France, where they all lived. They were Hitler's avowed enemies, besides which they had left all their possessions in Meudon. Arp wanted to go to the United States and start a new Bauhaus. He was very nervous about the war. All his predictions had come true and he saw the future in very gloomy terms. He was madly anti-German and would turn off the radio

if Mozart or Beethoven came over the air. He had been born in Alsace, but was now a Frenchman with the name of Jean instead of Hans, which he had dropped.

By the end of the summer, I received my cases of pictures. The Germans had come and gone from Vichy without even noticing them in Maria Jolas' barn; Giorgio Joyce, James's son, shipped them to Annecy, where they remained on the *quai de petite vitesse* for weeks. We did not know that they had arrived, and when we found out, we covered them with tarpaulins, but did not know what to do with them.

Being Jewish, I could not go back to Paris, but I wanted to exhibit the pictures somewhere. Nellie was a friend of Monsieur Farcy, the director of the Musée de Grenoble. He liked modern art, so I sent her to see him and asked for his help. She came back with no definite promise, but with an invitation to me to send the pictures to the museum at Grenoble, where he would at least shelter them. We immediately dispatched them, and Nellie and I followed and settled in Grenoble.

M. Farcy was in a very bad jam himself at this time. Because of the Vichy government he nearly lost his museum directorship and finally ended up in prison. He could not do much for me. Though he did want to exhibit my collection, he was too frightened. As he was expecting Pétain to visit Grenoble, he had hidden all the museum's modern pictures in the cellar. He gave me perfect freedom in the museum to do anything with my pictures except to hang them. I had a beautiful room where I placed them along the wall and could show them to my friends, photograph them and catalogue them. But he would never fix a date for a show, claiming that he must pave the way with the Vichy government

first, so much were they under Hitler's control. He did not want me to remove the pictures either, and after six months in Grenoble, I lost my patience and told him that I was going to America. He begged me to leave the collection with him, but I had no such intention. I had no idea how to send it to America, but I knew I would never leave without it.

M. Farcy was a very funny fat little man in his fifties. In his youth he had been a cyclist and had done the *tour de France*. One could hardly believe it from his present appearance. He liked to get away from home and from his adoring wife, and whenever we invited them for dinner he came alone, with an excuse from her about being unable to accompany him. Later we discovered that he had never conveyed our invitation to her. He loved modern art, but he couldn't distinguish one thing from another. He often asked me who had painted my paintings, and invariably when he came round to Marcoussis he said, 'What, Brancusi?' I had one painting by Vieira da Silva that he liked, because he thought it was a Klee. When I finally left Grenoble, I offered him either this painting or a Tanguy for a present. But when he asked me for the hundredth time if it were a Klee and I said, 'No,' he chose the Tanguy. In spite of all this, he loved modern art and managed to collect quite a few paintings for his museum without any funds. It was because of his taste, which the Germans hated, that he nearly lost his job with the Vichy government.

Laurence Vail now decided that it would be safer for me to go to America in the spring and take our children.

78

We were perpetually threatened with German occupation of all of France, and we knew that the United States would sooner or later enter the war and then we would be cut off from all financial resources. The American consuls, too, were urging us to go home. Worse still was the fear that I, as a Jewess, would be put in a concentration camp. I wanted to go to Vichy to ask our Ambassador to help me get my collection to America, but it was a very cold winter and we were snowbound. So my hands were tied.

Just at this time, René le Fevre Foinet arrived in Grenoble. He was one of the partners of the firm who had done all my shipping and packing from Paris to London when I had the gallery there. I told him my troubles, and to my great surprise he said nothing could be easier than to ship my collection to New York as household objects, provided I could send some personal belongings with it. He suggested my little Talbot car, which I had left in a garage for six months, as there was no more petrol in France for civilians. The only trouble was that I had forgotten which garage. We went to every garage in Grenoble before we found it, and then we went to work and packed up the whole collection, and René sent it off with some sheets and pots and pans.

During my stay in Grenoble, I received a cable from Tanguy's new wife, Kay Sage. She had taken him to America and was now trying to help other European artists to get there. She wanted me to pay the passage of five 'distinguished' artists. When I cabled to inquire who they might be, I received the reply: *André Breton, his wife and child, Max Ernst and Dr Mabille, the Surrealist doctor*. I protested, saying that neither Breton's wife nor his child, nor Dr Mabille were distinguished

79

artists, but I did accept the charge of the Breton family and Max Ernst. I was also trying to get Victor Brauner, who was a Jew, to America. He was in hiding as a shepherd in the mountains near Marseilles, and since Breton was in Marseilles, I went there to visit the Emergency Rescue Committee, which was doing a splendid job. It was run by Varian Fry, who raised a lot of money which he distributed among stranded refugees who were in hiding from the Gestapo. He worked underground to get them into Spain and Portugal or Africa, and from there to America or Cuba. He also helped to repatriate British soldiers who were still in France after Dunkirk and wanted to join De Gaulle.

Fry lived in an enormous dilapidated château called 'Belle Air', outside Marseilles. For assistants he had a former secretary of the prefect of police of Paris and his British wife. The Breton family were his guests. They had all been arrested and held incommunicado on a boat for several days during Pétain's visit to Marseilles.

Fry asked me to work with the committee. He wanted me to take his place while he was absent in the United States for a brief period. After consulting the American consul, I decided not to. The committee were doing a very dangerous job, of which I had absolutely no knowledge or experience, but I gave them a lot of money and went back to Grenoble.

After I had promised to pay Max Ernst's passage to America, Laurence Vail suggested that I ask Max to give me a painting in exchange. He wrote to say he would be delighted to do so, and sent me a photograph of one which I did not feel very enthusiastic about. I wrote back to say I might prefer another one. In the meantime he had written me asking me to send him six

80

Myself with Grace Hartigan's painting

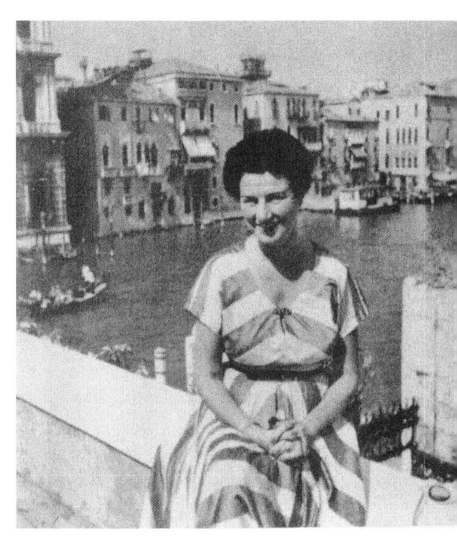

The view from my roof

thousand francs and a letter for a lawyer, testifying that I had seen his own sculptures in his house in the Ardèche and that they were worth at least seventy-five thousand francs. It seems Leonora Carrington had gone mad and made over their house to a Frenchman to save it from the Germans, but he turned out to be a crook and stole everything. Max hoped at least to recover his sculptures. I had seen them reproduced in *Cahiers d'Art* and could render him this service. His paintings he sneaked out at night. I had suggested going to see him in the Ardèche to choose a picture, but under the circumstances he could not receive me and told me to come instead to Marseilles.

LIFE WITH MAX ERNST

LIFE WITH MAX ERNST

When I arrived in Marseilles for the second time, the whole atmosphere of the château had changed. Breton no longer held court there, with his Surrealist followers playing games and making collective drawings. He had left for America. The Surrealist court also had disappeared, but Max was living there. He had been in many concentration camps and looked much older. He had never taken up French citizenship and was first imprisoned by the French for being German, and later by the Germans for being their avowed enemy. Finally, Leonora Carrington had managed to get him free; the Museum of Modern Art was now trying to get him to America. However, nothing came through in the way of documents and money, and his passport was about to expire.

I chose a great many of his pictures from every period, which he sold me for two thousand dollars, and then we celebrated his fiftieth birthday at the *vieux port*, drinking wine he had brought from the Ardèche, and eating oysters.

I felt extremely attracted to Ernst, and soon discovered that I was madly in love with him; from then on my only thought was to save him from Europe and get him to New York. After great difficulties, I managed to get him off to Lisbon. He left with all his paintings,

which were greatly admired at the frontier by soldiers at the customs, and even by priests.

When I finally got to Lisbon, he had found Leonora, whom he had lost during the war. After two months of dreadful complications and miseries on all sides, Leonora married a Mexican friend and went to New York with him, and Max left with me and my family.

When we arrived in New York on July 14, 1941, it was fourteen years since I had set foot in America. We were met by many friends, including Putzel and Max's son Jimmy. He had enormous blue eyes and was so tiny and fragile he looked like a miniature. Just as Max was about to greet Jimmy, he was seized by officials and not allowed to talk to him. It seemed that Pan-American Airways could not accept the responsibility of admitting a German into the United States without an investigation. I offered bail, but to no avail. Poor Max was whisked away. I gathered from the officials that the last boat had left for Ellis Island so, guarded by a detective, Max would have to spend the night in a hotel as the guest of Pan-American Airways. He was not supposed to talk to anyone, but they said they would let me know where he was being taken, and the rest would be up to me.

I followed Max to the Belmont-Plaza and took a room there. Then I phoned him every half hour. After the third call, he told me the detective had given him permission to meet me in the hotel bar called the Glass Hat. I went there with Putzel, and the three of us had a drink. Then the detective, who called me Max's 'sister', suggested we all have dinner in Max's room. We said we preferred to go out, and the detective gave his consent. He followed us through the streets at a

respectful distance and refused to join us at dinner, but remained alone at the bar of our little restaurant. After dinner, he wished to take us to Chinatown, but we said we preferred Pierre's Bar. He told us not to waste our money. Suddenly he chucked me under the chin and said, 'Peggy is a wonderful girl.'

When we went back to the Belmont-Plaza he asked Max if he did not want to sleep with 'his sister', saying it was perfectly safe, as he would be sitting outside Max's door all night with a gun in his pocket, guarding not only him but a G-man in the room opposite. I declined his offer.

The next morning, he turned Max over to an official of Pan-American Airways. The minute we landed at Ellis Island, Max was taken away and imprisoned. I was quite frantic for three days, waiting on the Island, where I went every day, expecting to be called as a witness. Max enjoyed himself immensely on the island and was not in the least worried, but I never saw him again until he was released. Jimmy, his son, came to the hearing with a letter from the Museum of Modern Art, and Max was released at once. When I told Max that he was a baby deposited on my doorstep, he said, 'You are a lost girl.' I knew he was right, but was surprised that he realized it.

I had no idea how famous Max was, and it was great fun going around with someone so well known. He was also perpetually encountering people whom he had known in concentration camps. To me these people seemed like ghosts, but to Max they were very real, and he always mentioned the dreadful camps where they had been together as though he were talking about Deauville, Kitzbuhl or St Moritz.

CONFESSIONS OF AN ART ADDICT

Max loved to wear fantastic clothes. In Europe he wore a black cape, which was very romantic and suited him perfectly. In Marseilles once, when I was buying a little sheepskin jacket, Max was so jealous that I had to order one for him as well. The furrier was very surprised, but he made it, and when Max wore it he looked like a Slav prince. I also gave him my mother's lorgnon, which made him look very aristocratic.

While Max was on Ellis Island I went to see Breton. He was installed in an apartment in Greenwich Village which Kay Sage Tanguy had rented for him for six months. It was very comfortable, but looked unlike his usual surroundings. There were no modern paintings and none of his collection of primitive art, which he must have missed terribly. He seemed worried about the future, yet in spite of this he was determined not to learn a word of English. Breton was anxious to get Max back into his group again, as Max was his biggest star and he had lost him during the Eluard crisis, when the Surrealists had split into two camps, Breton leading one and Paul Eluard the other. The Surrealists were always playing cat and mouse, and it was quite easy for Max to be seduced again. The person Breton objected to most was Dali, because of his commercial and vulgar attitude towards publicity. So Max would not allow me to see him. I promised Breton two hundred dollars a month for a year to put his mind at rest until he knew what he would do in New York. Later, he got a job broadcasting on the Free French radio.

In New York Breton continued to lead his usual life as much as he could. It was, however, in the home of Mr and Mrs Bernard Reis that he had the freest hand. They were art patrons, and she was a marvellous cook.

They gave many parties and invited all the Surrealists, whose art reviews they sponsored, especially *Triple V*. Mrs Reis loved to fill her home with Surrealists and let them do what they liked. Breton took advantage of this to make us all play his favourite game, *Le Jeu de la Verité*. We sat around in a circle while Breton lorded it over us in a true schoolmasterly spirit. The game was rather Freudian. It was a sort of psycho-analysis done in public. The worse things we exposed, the happier everybody was. One was asked what one would do about sex if one's husband went to war, and how long one could go without it, or what one's favourite occupation was. I once asked Max if he preferred to make love at the age of twenty, thirty, forty or fifty. He said, 'At fifty.' It was all ridiculous and childish, but the funniest part of all was the seriousness with which Breton took all this. He was mortally offended if anyone spoke out of turn. Part of the game was to inflict punishment on those who did so. Then he made you pay a forfeit. He ruled us with an iron hand, screaming, *'Gage'* at every moment. You were punished by being brought in blindfolded and forced on all fours, then you had to guess who had kissed you, or something equally foolish.

After we had been in New York for a while, my sister Hazel invited us to California. Max was delighted to go, and we took his son Jimmy and my daughter Pegeen. I particularly wished to go to see the Arensberg collection, which was then in California, and it was well worth the trip. The Victorian house was filled with Duchamp's paintings, Brancusi's sculptures and much pre-Columbian art, besides a lot of very fine Cubist and other paintings. They all looked funny in this setting. Even the bathrooms contained works of art. Arensberg

was a sad man, who seemed to be more interested in the Bacon–Shakespeare theory than in his collection. Today it looks magnificent in the Philadelphia Museum, beautifully installed by Henry Clifford, and poor Mr Arensberg is dead.

We went to Arizona and New Mexico and New Orleans, perpetually in search of a house wherein to install my museum. Max fell in love with kachina dolls and Indian masks. He wanted to buy everything he saw.

The place I came nearest to buying was a fifty-room unfinished castle built on a high hill at Malibu in Southern California. In its unfinished state it looked like a Surrealist dream. In Marseilles I had inadvertently invited Beton to live in my museum in America and hold his court there. This would have been the perfect place for such activities, but it was too far away from any city, so we gave it up.

Then we tried New Orleans, a most fascinating town, but it seemed too remote from the world and too hot and provincial. San Francisco was a lovely city, but did not need me or my museum, as Dr Grace McCann Morley was already doing a wonderful job there as director of the San Francisco Museum.

When we got back to New York we continued looking for a house. We finally found a dream of a house on Beekman Place which we couldn't resist. Unfortunately, we were not permitted to make a museum there. It was a remodelled brownstone mansion called Hale House, on the East River and 51st Street. It had a big living-room which looked like a chapel, with an old fireplace that might well have come out of some baronial hall in Hungary. The chapel was two stories high and the whole front of the room gave on to the River, where we

had a terrace. There was a balcony above, with five little windows overlooking the chapel. Here five choir boys might well have sung chants. Above we had a bedroom, and Max had a studio with another terrace. There were other rooms for my daughter and for guests. When we were alone we ate in the kitchen, where Max and I both loved to cook.

Soon after Pearl Harbor we were married, as I did not want to live in sin with an enemy alien.

When we arrived in America we had expected a warm reception from Alfred Barr, director of the Museum of Modern Art, but he was in Vermont and we did not see him until the fall. His books had been my bibles for years and I was longing to meet him. When I did so, I was surprised how much he resembled Abraham Lincoln. I liked him at once. He was shy but charming, and his conversation was serious and learned and stimulating. He was impressed by my passion for art. He wanted to buy a painting of Max's for the Museum of Modern Art, but as my Aunt Olga, his guardian angel, only gave him money to buy the most expensive paintings, he could never raise the funds he needed. So in the end he gave me a Malevich (of which he had thirteen) which had been smuggled out of Russia in an umbrella, and I gave Max five hundred dollars and Barr got Max's painting.

When we moved into Beekman Place we gave a huge house-warming. Unfortunately there was a terrible fight between giant Nicco Callas, the art critic, and little Charles Henri Ford, the poet. Jimmy Ernst, who was my secretary, rushed to take down my Kandinsky, fearing it would be spattered with blood. Barr thought it was real devotion on Jimmy's part to rescue my painting before Max's.

91

Max took me to many museums. He called the Modern Museum the Barr house, and the Guggenheim museum· (my uncle's collection), the Bauer House, and the Gallatin collection, now in Philadelphia, the Bore house. He liked the Museum of Natural History, where he decided the mathematical objects were much better than Pevsner's constructions, but what he really preferred was the Museum of the American Indian, the Hay Foundation, where Breton took us. It has undoubtedly the best collection in the world of British Columbian, Alaskan, pre-Columbian, Indian and Mayan art. Max was in constant communication with a little man called Carlebach, who produced wonderful things for him from all these places, so our house soon became full of them, and as we had practically no furniture, it looked very beautiful. Carlebach was perpetually scurrying round and finding things with which to tempt Max and phoning him.

When Carlebach discovered that I collected ear-rings, he immediately got together a large quantity and began to work on me. But I did not succumb. Of course, Max did. He bought me a beautiful pair with Spanish baroque pearls. But I resisted any further efforts on the part of Carlebach, as I considered him sufficiently dangerous with his masks and totem poles. The last one Max bought was twenty feet high. He also bought an old Victorian chair with a ten-foot back. It was a stage piece and he would not let anyone else sit in it, except my daughter. He looked regal in it, or more like a matinée idol. At one period, he filled the house with American wooden horses. He was selling more and more pictures in New York, with my aid and Putzel's, and could well afford luxuries of this sort, especially as he refused to

contribute to our household expenses and never put a cent aside for his income tax.

The paintings Max had done in France between periods of concentration camps, or while he was actually in them, started a completely new phase of his work. The backgrounds of these paintings resembled the desert land of Arizona and the swamps of Louisiana, which we were soon to visit together. It seems to have been his special gift to forepaint the future. As his painting was completely unconscious, and came from some deep hidden source, nothing he ever did surprised me. At one time when he was alone in France, after Leonora had left, he painted her portrait over and over again in all the landscapes that he was so soon to discover in America. I was jealous that he never painted me and it was a cause of great unhappiness.

One day when I went into his studio I had a great shock. There on his easel was a little painting I had never seen before. In it was portrayed a strange figure with the head of a horse. It was Max's own head with the body of a man dressed in shining armour. Facing this strange creature, with her hands between his legs, was a portrait of me, but not of me as Max had ever seen me. It was my face at the age of eight. I have photographs of myself at this age and the likeness is unquestionable. I burst into tears and told Max he had at last painted my portrait. He was rather surprised, as he had never seen the photos. Because my hand was placed where it was, and because it was between two spears, I named the painting 'Mystic Marriage'. At my request Max gave me this painting. Later he painted an enormous canvas of this same subject, slightly changing it, and my lovely little innocent child's head turned into

93

CONFESSIONS OF AN ART ADDICT

that of a terrible monster. He called the big painting 'Anti-Pope'. I own both of them and they now bear the same title.

In New York I kept on buying paintings and sculpture in order to complete Herbert Read's list. Many of the artists had left Paris and were living in New York, so the atmosphere was very exciting and stimulating. Breton and Max went about with me to galleries and helped me to choose. Putzel showed up too and continued his exertions. I was also very busy completing the catalogue I had started in Grenoble. Max did a beautiful cover for it and helped me a lot with the layout. I was rather worried about this catalogue, however, and decided it was very dull. I asked Breton to save it. He was always telling me it was 'catastrophique', which it probably would have been, had it not been for him. He spent hours of research and found statements made by each artist represented in the collection. We included all these statements in the catalogue, as well as photographs of their eyes. Breton's introduction, translated by Laurence Vail, was excellent, containing a whole history of Surrealism. I got Mondrian to do another introduction for me as well and also used the one Arp had written for me in Europe. Breton made me add the manifestos of the different movements in art in the last thirty years. We also included statements made by Picasso, Max, de Chirico, and others.

The catalogue, which I named *Art of This Century*, was produced by the Art Aid Corporation and sold in all the bookshops in New York, and eventually all over the world. It sold very well, but unfortunately there were only two thousand copies. The bookshops made lovely windows for me, and I was terribly excited. Jimmy, my

stepson and secretary, helped me a great deal in all this and was excellent about advance publicity.

I introduced Max to my aunt, Mrs Solomon Guggenheim. All my uncle's best paintings were in their suite in the Plaza Hotel, while their museum was full of awful enormous Bauers in heavy silver frames. When I told my aunt to burn them all she said, 'Don't let your uncle hear that, he has invested a fortune in them.' She said with much perspicacity that she considered Dali was to Max what Bauer was to Kandinsky.

ART OF THIS CENTURY

ART OF THIS CENTURY

Finally I found a top story in West 57th Street for my museum. I didn't know how to decorate it, and Putzel, as usual on hand said, 'Why don't you get Kiesler to give you a few little ideas?' Frederik Kiesler was one of the most advanced architects of this century. So I accepted Putzel's suggestion, never dreaming that the few little ideas would end up in my spending seven thousand dollars.

Kiesler was a little man about five feet tall, with a Napoleonic complex. He was an unrecognized genius, and I gave him a chance, after he had been in America for fifteen years, to do something really sensational. He told me that I would not be known to posterity for my collection, but for the way he presented it in his revolutionary setting.

Kiesler really created a wonderful gallery—very theatrical and extremely original. If the pictures suffered from the fact that their setting was too spectacular and took away people's attention from them, it was at least a marvellous décor and created a terrific stir.

The only condition I had made was that the pictures should be unframed. Otherwise Kiesler had *carte blanche*. I had expected that he would insert the pictures into the walls. I was quite wrong: his ideas were much more original. In the Surrealist gallery he put curved walls made of South American gum wood. The unframed

paintings, mounted on baseball bats, which could be tilted at any angle, protruded about a foot from the walls. Each one had its own spotlight. Because of Kiesler's theatrical ideas, the lights, to everybody's dismay, went off every three seconds. That is, they lit only half the pictures at a time. People complained, and said that if they were looking at a painting on one side of the room, the lights suddenly went off and they were forced to look at some other painting that was lit instead of the one they wanted to see. Putzel finally put an end to this and the lighting system became normal. In the abstract and Cubist gallery where I had my desk, near the entrance, I was perpetually flooded in a strong fluorescent light. Two walls, consisting of an ultramarine canvas curtain like a circus tent, attached to the ceiling and floor by strings, curved around the room in various sweeps. The floor was painted turquoise.

The paintings, which were also hung on strings from the ceiling, and at right angles to the walls, looked as though they were floating in space. Little triangular shelves of wood supported the sculptures, which also seemed to float in the air. Kiesler had designed a chair out of plywood and various coloured linoleums, which could be used for seven different purposes. It could serve as a rocking chair, or it could be turned over and used as a stand for paintings or sculpture, or as a bench, or table, and it could also be combined in different ways with planks of wood to increase the seating capacity. The gallery was supposed to seat ninety people for lectures, so there were also little folding chairs covered in ultramarine blue canvas, like the curtain. Kiesler also produced an ingenious stand which, at the same time, served as storage space for the drawings and a

place to exhibit them. This saved much space, which I needed.

There was a beautiful daylight gallery that skirted the front of 57th Street, which was used for monthly shows. Here pictures could be shown in frames on plain white walls. In order to temper the light, Kiesler put a flat ninon screen a few inches in front of the window. In one corridor he placed a revolving wheel on which to show seven works of Klee. This wheel automatically went into motion when the public stepped across a beam of light. In order to view the entire works of Marcel Duchamp in reproduction, you looked through a hole in the wall and turned by hand a very spidery looking wheel. The press named this part of the gallery 'Coney Island'. Behind the blue canvas, I had an office, which I never used, as I wanted to be in the gallery all the time to see what was going on.

The opening night, October 20, 1942, was dedicated to the Red Cross, and tickets were sold for a dollar each. Many of the invitations were lost in the mail, but hundreds of people came. It was a real gala opening. I had a white evening dress made for the occasion, and wore one of my Tanguy ear-rings and one made by Calder, in order to show my impartiality between Surrealist and abstract art. The last days we worked day and night to get the gallery ready in time, but workmen were still on the premises when the press arrived in the afternoon before the opening.

We had great money difficulties. More and more bills kept coming in. Finally, when I realized how much Kiesler's total cost exceeded his estimate, I practically broke with him and refused to let him come to my house, but I maintained a formal museum façade.

I was so excited about my life in the museum that I neglected Max and my home, which did a great deal of harm to our marriage. But we had a lot of parties in the evening and entertained all Breton's and Max's followers, besides the abstract painters, and a great many young American ones.

My first secretary in the gallery, which I named Art of This Century, after my catalogue, was Jimmy Ernst. Later, when he left me, Putzel came to work with me. The first show was dedicated to my collection. Fourteen of Max's paintings and *collages* were on exhibition, more than those of any other painter; naturally, as I owned so many. Kiesler and I had not permitted anyone to see the gallery before it was finished—even Max was not admitted. When he finally saw his paintings, taken out of all their fancy and expensive frames, he made a great fuss, but when he saw how well all the other paintings looked he decided not to be difficult.

The publicity we got was overwhelming. Photographs appeared in all the papers. Even if the press didn't altogether approve of Kiesler's ultra-revolutionary ideas, at least they talked enough about the gallery to cause hundreds of people to come to see it every day.

The next show as an exhibition for three artists' works: Laurence Vail's decorated bottles, Joseph Cornell's Surrealist objects, and Marcel Duchamp's valise, a little pig-skin suit-case he had invented to contain all the reproductions of his works. I often thought how amusing it would have been to have gone off on a week-end and brought this along, instead of the usual bag one thought one needed.

The third show was dedicated to the works of thirty-one women. This was an idea Marcel had given me in

Paris. The paintings submitted were judged by a jury consisting of Max, Marcel, Breton, the critics James Johnson Sweeney and James Soby, Putzel, Jimmy Ernst and myself. Edward Alden Jewell, art critic for the *New York Times*, wrote a long article about this show in which he said, 'The elevator man at Art of This Century, who is tremendously interested in art, told me on the way up that he had given the place an extra thorough cleaning because Gypsy Rose Lee, one of the exponents, was coming.'

I made Max work very hard for this show. He had to go around to all the women and bring their paintings to the gallery in his car. He was interested in women who painted. There was one called Dorothea Tanning, a pretty girl from the Middle West. She was quite talented, and imitated Max's painting, which flattered him immensely. They now became very friendly and played chess together while I was in the gallery. Soon they became more than friendly and I realized that I should only have had thirty women in the show. This was destined to end our marriage.

Edward Jewell, commenting in the *New York Times* on the opening of the Surrealist gallery said: 'It looks faintly menacing—as if in the end it might prove that the spectator would be fixed to the wall and the art would stroll around making comments, sweet or sour, as the case might be.'

On one occasion we had a visit from Mrs Roosevelt. Unfortunately this honour was not due to her desire to see modern art. She was brought by a friend to see a photographic exhibition of the Negro in American life. Mrs Roosevelt was extremely cordial and wrote enthusiastically about the exhibition in her column.

Before she left I did my best to make her go into the Surrealist gallery, but she retired through the door sideways, like a crab, pleading her ignorance of modern art. An English friend of mine, Jack Barker, had come up in the elevator with Mrs Roosevelt and her friend, and followed them into the gallery, mimicking the gracious high falsettoes with which they greeted me. Mrs Roosevelt, evidently amused by his behaviour, turned to him smiling, and bowed. The embarrassed Barker, unable to recall how well he knew this lady, whose face was so familiar, was uncertain whether to fling himself into her arms, clasp her warmly by the hand, or bow back in a reserved manner. In such a dilemma he decided to ignore the whole thing, and failed to return the gracious salutation.

In London, in 1939, Herbert Read had conceived the idea of holding a spring salon. In 1941, I decided to try it out in New York. I appointed a jury. The members were Barr, Sweeney, Soby, Mondrian, Duchamp, Putzel and myself. The first year it worked very well, and out of the pickings we had a very fine show of about forty paintings. The stars who emerged were Jackson Pollock, Robert Motherwell and William Baziotes. They had all three shown their work in a previous show of *collages* in my gallery. As it was non-commercial, Art of This Century soon became a centre for all *avant-garde* activities. The young American artists, much inspired by the European abstract and Surrealist artists who had taken refuge in New York, started an entirely new school of painting, which Robert Coates, art critic for the *New Yorker*, named Abstract Expressionism.

We had the great joy of discovering and giving first one-man shows not only to Pollock, Motherwell and

Baziotes, but also to Hans Hoffmann, Clyfford Still and Mark Rothko and David Hare. The group shows included Adolph Gottlieb, Hedda Sterne and Ad Reinhardt. We also gave one-man shows to de Chirico, Arp, Giacometti, Helion, Hans Richter, Hirshfield, van Doesburg, Pegeen and Laurence Vail and I. Rice Pereira. We also held several spring salons, gave another woman's show, two *collage* shows, and exhibited the work of various unknown artists.

After the first spring salon it became evident that Pollock was the best painter. Both Matta, the painter who was a friend of mine, and Putzel urged me to help him, as at the time he was working in my uncle's museum as a carpenter. He had once been a pupil of the well-known academic painter, Thomas Benton, and through his terrific efforts to throw off Benton's influence had, in reaction, become what he was when I met him. From 1938 to 1942 he had worked on the w.p.a. Federal Act Project for artists, which was part of the scheme originated by President Roosevelt for reducing unemployment.

When I first exhibited Pollock he was very much under the influence of the Surrealists and of Picasso. But he very soon overcame this influence, to become, strangely enough, the greatest painter since Picasso. As he required a fixed monthly sum in order to work in peace, I gave him a contract for one year. I promised him a hundred and fifty dollars a month and a settlement at the end of the year, if I sold more than two thousand seven hundred dollars' worth, allowing one-third to the gallery. If I lost I was to get pictures in return.

Pollock immediately became the central point of Art of This Century. From then on, 1943, until I left

105

America in 1947, I dedicated myself to Pollock. He was very fortunate, because his wife Lee Krassner, a painter, did the same, and even gave up painting at one period, as he required her complete devotion. I welcomed a new protégé, as I had lost Max. My relationship with Pollock was purely that of artist and patron, and Lee was the intermediary. Pollock himself was rather difficult; he drank too much and became so unpleasant, one might say devilish, on these occasions. But as Lee pointed out when I complained, 'He also has an angelic side,' and that was true. To me, he was like a trapped animal who never should have left Wyoming, where he was born.

As I had to find a hundred and fifty dollars a month for the Pollocks, I concentrated all my efforts on selling his pictures and neglected all the other painters in the gallery, many of whom soon left me, as Sam Kootz, the art dealer, gave them contracts, which I could not afford to do.

I commissioned Pollock to paint a mural for my entrance hall, twenty-three feet wide and six feet high. Marcel Duchamp said he should put it on a canvas, otherwise it would have to be abandoned when I left the apartment. This was a splendid idea, and—for the University of Iowa—a most fortunate one, as I gave it to them when I left America. It now hangs there in the students' dining hall.

Pollock obtained a big canvas and tore down a wall in his apartment in order to make room to hang it up. He sat in front of it, completely uninspired for days, getting more and more depressed. He then sent his wife away to the country, hoping to feel more free, and that when alone he might get a fresh idea. Lee came back and found

him still sitting brooding, no progress made and nothing even attempted. Then suddenly one day he got up and in a few hours painted a masterpiece.

The mural was more abstract than Pollock's previous work. It consisted of a continuous band of abstract figures in a rhythmic dance painted in blue and white and yellow, and over this black paint was splashed in drip fashion. Max Ernst had once invented, or set up, a very primitive machine to cover his canvases with drip paint. It had shocked me terribly at the time, but now I accepted this manner of painting unhesitatingly.

We had great trouble in installing this enormous mural, which was bigger than the wall it was destined for. Pollock tried to do it himself, but not succeeding, he became quite hysterical and went up to my flat and began drinking from all the bottles I had purposely hidden, knowing his great weakness. He not only telephoned me at the gallery every few minutes to come home at once and help place the painting, but he got so drunk that he undressed and walked quite naked into a party that Jean Connolly, who was living with me, was giving in the sitting-room. Finally, Marcel Duchamp and a workman came to the rescue and placed the mural. It looked very fine, but I am sure it needed much bigger space, which it has today in Iowa.

I felt Pollock had a deep feeling for West American-Indian sculpture, as it came out a lot in his earlier paintings, and in some of those that were to be in his first exhibition. This was held in November, 1943. The introduction to the catalogue was written by James Johnson Sweeney, who helped a lot to further Pollock's career. In fact, I always referred to Pollock as our

spiritual offspring. Clement Greenberg, the critic, also came to the fore and championed Pollock as the greatest painter of our time. Alfred Barr bought the 'She Wolf', one of the best paintings in this show, for the Museum of Modern Art. Later, Dr Morley asked for the show in her San Francisco Museum, and bought the 'Guardians of the Secret'.

We did not sell many Pollock paintings, but when he gave us gouaches it was much easier. A lot of these I gave away as wedding presents to my friends. I worked hard to interest people in his work and never tired doing so, even when it involved dragging in and out his enormous canvases. One day Mrs Harry Winston, the famous Detroit collector, came to the gallery to buy a Masson. I persuaded her to buy a Pollock instead.

In 1945, Bill Davis, the collector, who was also a fan of Pollock's, advised me to raise my contract with him to three hundred dollars a month, and in exchange, to take all Pollock's works. Pollock was very generous in giving me presents. At this time I had acute infectious mononucleosis, and during the annual Pollock show had to stay in bed. This distressed Lee Pollock very much, as she said no one could sell anything in the gallery except me, and Putzel had left to set up his own gallery in New York. Poor man, this proved to be a great tragedy, as it ended in his suicide.

Lee was so dedicated to Pollock that when I was sick in bed, she came every morning to try to persuade me to lend them two thousand dollars to buy a house on Long Island. She thought that if Pollock got out of New York he would stop drinking. Though I did not see how I could produce any extra funds I finally agreed to do so as it was the only way to get rid of Lee. Now it all

makes me laugh. I had no idea then what Pollock paintings would be worth. I never sold one for more than a thousand dollars and when I left America in 1947, not one gallery would take over my contract. I offered it to them all, and in the end Betty, of the Betty Parsons Gallery, said she would give Pollock a show, but that was all she could do. Pollock himself paid the expenses of it out of one painting Bill Davis bought. All the rest were sent to me, according to the contract, at Venice, where I had gone to live. Of course, Lee had her pick of one painting a year. When the pictures got to Venice, I gave them away one by one to various museums, and now only have two of this collection left, though I also have nine earlier ones dating from 1943 to 1946. And so now Lee is a millionaire, and I think what a fool I was.

In my struggles for Pollock I also had to contend with such things as Dorothy Miller absolutely refusing to include him in an exhibition of twelve young American artists—artists who were obviously what she considered the best we had—which she did in 1946, as a travelling show for the Museum of Modern Art. I complained to Alfred Barr, but he said it was Dorothy Miller's show and nothing could be done about it. I also had great money difficulties to keep both Pollock and the gallery going, and often found myself in the position of having to sell what I called an old master. Thus, I was once forced to part with a marvellous Delaunay of 1912, called 'Disks', which I had bought from him in Grenoble, when he was a refugee from occupied Paris. This picture later turned up in the Museum of Modern Art. Its loss is one of the seven tragedies of my life as a collector.

The second was my stupidity in not availing myself of the opportunity of buying 'La Terre Labourée', of Miró, in London in 1939 for fifteen hundred dollars. Now, if it were for sale, it would be worth well over fifty thousand.

The third tragedy was selling a 1936 Kandinsky, called 'Dominant Curve' in New York during the war, because I listened to people saying it was a fascist picture. To my great sorrow I later found it in my uncle's collection in an exhibition in Rome.

The fourth was not buying Picasso's 'Pêche de Nuit à Antibes', because I had no cash on hand, and did not have enough sense to sell some capital, which my friend and financial adviser, Bernard Reis, told me to do when the picture was offered to me in 1950; and now that, too, is in the Museum of Modern Art.

The fifth is having to sell a Henri Laurens sculpture and a beautiful Klee water-colour in order to pay Nellie van Doesburg's passage to New York; and the sixth, to have all but two of my last remaining Klees stolen from Art of This Century. But the worst mistake of all was giving away eighteen Pollocks. However, I comfort myself by thinking how terribly lucky I was to have been able to buy all my wonderful collection at a time when prices were still normal, before the whole picture world turned into an investment market.

As the gallery was a centre where all the artists were welcome, they treated it as a sort of club. Mondrian was a frequent visitor, and always brought his paintings carefully wrapped up in white paper. I had bought two of his beautiful large charcoal Cubist drawings from a gallery in New York, and these I much preferred to his later works, of which I also had one. When I once asked

him to clean one of his own paintings, which always had to be immaculate, he arrived with a little bag and cleaned not only his picture, but also an Arp and a Ben Nicholson relief. He admired Max's and Dali's paintings very much and said, 'They are great artists. Dali stands a little apart from the others, he is great in the old tradition. I prefer the true Surrealists, especially Max Ernst. They do not belong to the old tradition, they are sometimes naturalists in their own way, but free from tradition. I feel nearer in spirit to the Surrealists, except for the literary part, than to any other kind of painting.'

One night Mondrian invited me to his studio, which looked exactly like one of his paintings, and played boogie-woogie music for me on his gramophone. He kept moving strips of paper with which he was planning a new painting, and asked me which combination was best. I am sure he did not take my advice.

In the winter of 1946, I asked Alexander Calder to make me a bed-head, which I thought would be a marvellously refreshing change from our grandmothers' old brass ones. He said he would, but never got around to it. One day I met him at a party and said, 'Sandy, why haven't you made my bed?' At this strange question, Louisa, his wife, a beautiful niece of Henry James, pricked up her ears and urged Sandy to get to work. Because of the war, the only available material was silver, which cost more than all the work Sandy did on it. It was not mobile, except for the fact that it had a fish and a butterfly that swung in space from the background, which resembled under-sea plants and flowers. I am not only the only woman in the world who sleeps in a Calder bed, but the only one who wears his enor-

mous mobile ear-rings. Every woman in New York who is fortunate enough to be decorated by a Calder jewel, has a broach or a bracelet, or a necklace.

After Morris Hirshfield's death, Sydney Janis, the dealer, asked me to give him a memorial show. It was very beautiful, and I acquired what I consider his best painting, 'Two Women before the Looking-Glass'. It portrays the women perfuming themselves, combing and brushing their hair and putting on lipstick. It is unrealistically presented, with the women seen back to front in the mirror. They also have four bottoms, which, when the painting was hung in my entrance hall, received many pin-pricks from sensuous admirers who were passing through the hall.

In the summer of 1945 my great friend Emily Coleman came to see me, and brought with her a fantastic creature called Marius Bewley. I have never met anyone like him in my life. He looked like a priest, which he had once intended to be, and spoke with a strange false English accent. I took to him at once, and immediately asked him to come and be my secretary in the gallery. He accepted just as readily, as he thought the idea very pleasant. Our collaboration was a great success. We became tremendous friends and have remained so ever since, though Marius left me after a year to go to take a ph.D. at Columbia University. He was extremely learned and a brilliant writer, and everything he said was brilliant too. He had a marvellous sense of life and of humour. He loved modern pictures, and though he sold very few, he bought a lot from my gallery.

After Marius left me, he sent in his place a very strange young man who couldn't type and who never appeared on time—in fact, some days not at all. I was

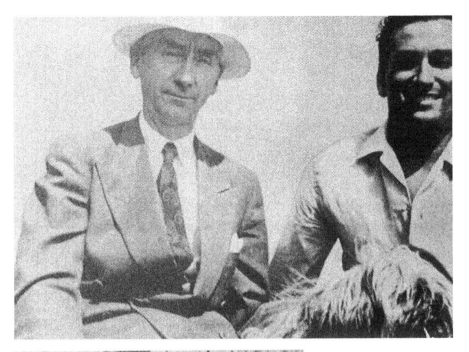

The two Sir Herberts
and Raoul

With Bacci and Tan-
credi in my garden

In my barchessa

kept very busy answering the telephone for him, as his friends never stopped phoning him. The only thing he liked to do was to take my Lhasa terriers for walks, as they served as introductions to other fascinating Lhasa terriers who belonged to such distinguished people as Lily Pons, John Carradine and Philip Barry and others. The original Lhasa had been given to Max Ernst, but when we were divorced he had taken it away with him. I had wanted very much to retain this darling dog, Kachina, for half the year, and wished to have this put in the divorce contract, but it was too complicated and I had to content myself, years later, with two of her puppies, which Max sold me at birth.

Much as I loved Art of this Century, I loved Europe more than America, and when the war ended I couldn't wait to go back. Also, I was exhausted by all my work in the gallery, where I had become a sort of slave. I had even given up going out to lunch. If I ever left for an hour to go to a dentist, oculist or hairdresser, some very important museum director would be sure to come in and say, 'Miss Guggenheim is never here'. It was not only necessary for me to sell Pollocks and other pictures from current shows, but I also had to get the paintings circulated in travelling exhibitions. The last year was the worst, when my secretary couldn't even type, and this extra burden was added to my chores. I had become a sort of prisoner and could no longer stand the strain. Levi Straus, the French cultural attaché, gave me a letter to the French Consul, saying I had to go abroad to see French and European art, and with this excuse I got to Paris and then to Venice, where Mary McCarthy and her husband, Boden Broadwater, insisted that I accompany them.

On my way there, I decided Venice would be my future home. I had always loved it more than any place on earth and felt I would be happy alone there. I set about trying to find a palace that would house my collection and provide a garden for my dogs. This was to take several years; in the meantime I had to go back to New York to close the gallery. We ended it with a retrospective show of van Doesburg, which I arranged to have circulated all over the United States. Nellie van Doesburg came to New York from France as my guest, with all the pictures. I had been trying to arrange this during the war, but had not succeeded until it was too late for her to leave France.

I sold all Kiesler's fantastic furniture and inventions. There was terrific bidding for them, and to avoid complications I let them be removed by the cash and carry system. Poor Kiesler never even got one thing as a souvenir, they disappeared so quickly.

Betty Parsons fell heir to my work, spiritually, and as I said, promised Pollock a show. Happy to think that she was there to help the unknown artists, I left my collection in storage and flew to Europe with my two dogs, not to return for twelve years.

VENICE AND THE BIENNALE

VENICE AND THE BIENNALE

One of the first people I had met in Venice in 1946 was an artist called Vedova. I was in the Café Angelo at the Rialto. Not knowing anyone in Venice, I inquired of the *patron* where I might meet some modern artists. He said, 'Go to the other Angelo restaurant at San Marco and ask for Vedova.' I wrote this name on a matchbox and proceeded to the other Angelo. Here I received a wonderful welcome from Vedova and another Venetian artist, Santomaso, who both became my friends. They were very much interested in modern art, and knew about my uncle's collection, which surprised me. In fact, they even had the catalogue. As they spoke Venetian dialect together, I spent painful hours in their company, not understanding a word they said. But when I was alone with either of them it was better, as I could speak a little Italian.

Vedova, who painted abstractions, was an enormously tall man with a beard. He was a Communist and during the war had been a partisan. He was very young and mad about lovely young girls. Santomaso was less tall and rounder. He also had a roving eye, and a wife and child as well. He was extremely well versed in Venetian history and recounted the most fascinating things of his great city's past. Of the two, he was the more cultivated. The Angelo restaurant was filled with their paintings and a great many other people's. This is a Venetian

custom: painters are allowed to eat free and give their works in return.

It was through Santomaso that I was invited to show my entire collection at the xxivth Biennale of Venice. He had suggested to Rudolfo Pallucchini, the secretary-general of the Biennale, that the collection should be exhibited, and it was agreed that it should be shown in the Greek pavilion, which was free because of the Greeks being at war.

The Biennale, which was started in 1895, is an international exhibition of contemporary art, which is held every other year in the Public Gardens at the end of Venice, on the lagoon near the Lido. A lot of very ugly buildings put up in the time of Mussolini give it a distinct character. The trees and the gardens are wonderfully looked after and make a beautiful background for the various pavilions. In the middle of June, when the Biennale opens, the lime trees are flowering and the perfume they exhale is overpowering. I often feel this must compete strongly with the exhibition, as it is so much pleasanter to sit in the gardens than to go into the terribly hot and unventilated pavilions.

The foreign countries that exhibit are each responsible for the shows in their own pavilions, which are run under the auspices of their various governments. In the main Italian pavilion there are miles and miles of very boring paintings, though occasionally something good is shown. There are also innumerable large and small one-man shows which are supposed to be devoted to contemporary painters, though sometimes earlier artists, such as Delacroix, Courbet, Constable, Turner, and even Goya have slipped in. No one knows why. Most of the Italians who exhibit go on doing so year after year out

of habit. There have also been one-man shows of Picasso, Braque, Miró, Ernst, Arp, Giacometti, Marini, Klee, Mondrian, Douanier Rousseau, as well as shows of the Fauves and the Futurists. Before 1948, only Picasso and Klee were known in Italy, apart from the Italian Futurists.

The Biennale is opened by the President of Italy, who comes in full pomp and regalia to inaugurate it, and the Venetian state boats of the past are brought out for the procession from the Prefettura, the Prefect's palace, to the Public Gardens.

In 1948, after so many years of disuse, the pavilions were in a bad state and there was an awful lot of repairing going on up to the last minute. My pavilion was being done over by Scarpa, who was the most modern architect in Venice. Pallucchini, the secretary-general, was not at all conversant with modern art. He was a great student of the Italian renaissance, and it must have been very difficult for him, as well as very brave, to do his task. When he gave a lecture in my pavilion he asked me to help him distinguish the various schools; he was even unfamiliar with the painters. Unfortunately I had to go to the dentist, but he claimed that he had managed without me.

Pallucchini was very strict and tyrannical. He reminded me of an Episcopalian minister. He would not allow me into the Gardens until my pavilion was finished. I was very upset, as everyone else in Venice who was interested in modern art seemed to be getting passes. Finally I was invited to come, and was taken all over by Pallucchini's aide-de-camp, a lovely man called Umbro Apollonio. I don't know how, but while talking to him I sensed that this was the first time in his life that

119

he was doing a job that he enjoyed, and my recognition of the fact touched him so much that we immediately became friends. Like Pallucchini, he knew nothing about modern art. In Italy, the Surrealists, Brancusi, Arp, Giacometti, Pevsner and Malevich had never been heard of. If Santomaso was conversant with what was going on outside Italy, it was only because he had been to Paris in 1945. Also, he and Vedova had both seen copies of *Minotaur* and *Cahiers d'Art*, brought clandestinely into Italy.

In 1948 the foreign pavilions were, naturally, *à la page*. But some were still very much behind the Iron Curtain. I was allowed to hang my collection three days before the Biennale opened. Actually, I wanted to go to Ravenna with Dr Sandberg, the director of the Stedelijk Museum in Amsterdam, who had already finished his work in the Dutch pavilion. But this was out of the question, so I buckled down to work. Fortunately I was given a free hand and a lot of efficient workmen, who did not mind my perpetual changes. We managed to get the show finished in time, and though it was terribly crowded it looked gay and attractive, all on white walls—so different to Kiesler's décor for Art of This Century.

The opening of the Biennale was very formal, but, as usual, I had no hat, stockings or gloves and was in quite a dilemma. I borrowed stockings and a girdle from a friend, and instead of a hat wore enormous marguerite-flowered ear-rings made out of Venetian glass beads. Count Zorzi, the head of the press office and the Ambassador of the Biennale, who had actually extended to me the Biennale invitation, gave me strict instructions that when President Einaudi came to my pavilion I

should try to explain to him as much as I could about modern art in the five minutes he would remain with me. I received exactly contrary orders from Pallucchini, who said the President was lame and would be terribly tired after visiting the whole Biennale, my pavilion being his last effort.

When His Excellency arrived he greeted me by saying, 'Where is your collection?' I said, 'Here,' and he corrected himself and asked where it had been before. I tried to obey Count Zorzi rather than Pallucchini, and put in a few words, but luckily the photographers intervened and the entire official party was photographed with Gonella, the Minister of Education, the President and me under my lovely Calder mobile.

The same morning I had a visit from the American Ambassador and the consular staff. The United States pavilion was not open, as the pictures had not arrived in time, and James Dunn, our Ambassador, was very pleased that at least I represented the United States. Looking at one of my abstract Picassos, he seemed rather happy to note that it was 'almost normal'.

The introduction to the Biennale catalogue for my show was written by Professor Argon. It was very confusing, as he was all mixed up about the different trends in modern art. Upon the insistence of Bruno Alfieri, the owner of a bookshop, I had made a little catalogue of my own to sell in my pavilion, although I was included in the Biennale one. I wrote a short introduction for my own catalogue, but it was so badly translated that I became quite hysterical and even wept. I could not speak Italian well enough to cope with the situation and begged Marga Barr, Alfred's wife, who is half Italian, and who was then in Venice, to help me. But the moment

I chose was on board a vaporetto and she had to get off before she could finish her task.

The two most unfortunate things that occurred at the Biennale were the theft of a little piece of bronze from a David Hare sculpture representing a baby; it must have been taken as a souvenir. And the other was Pallucchini's decision (as some priests were coming to visit my pavilion) to take down a very sexual Matta drawing of centaurs and nymphs. The drawing itself was so annoyed that it fell on the ground and the glass broke into smithereens, thus obviating its insulting removal.

A third catastrophe was avoided by Bruno Alfieri, who saved a dismantled Calder mobile from being thrown away by the workmen, who thought that it was bits of iron bands which had come off the packing cases.

My exhibition had enormous publicity and the pavilion was one of the most popular of the Biennale. I was terribly excited by all this, but what I enjoyed most was seeing the name of Guggenheim appearing on the maps in the Public Gardens next to the names of Great Britain, France, Holland, Austria, Switzerland, Poland, Palestine, Denmark, Belgium, Egypt, Czechoslovakia, Hungary, Roumania. I felt as though I were a new European country.

My next illustrious visitor was Bernard Berenson. I greeted him as he came up my steps and told him how much I had studied his books and how much they had meant to me. His reply was, 'Then why do you go in for this?' I knew beforehand how much he hated modern art and said, 'I couldn't afford old masters, and anyhow I consider it one's duty to protect the art of one's time.' He replied, 'You should have come to me, my dear, I would have found you bargains.' He liked best the works

122

of Max Ernst and Pollock. Nevertheless, he said Max's were too sexual and that he did not like sex in art; the Pollocks, to him, were like tapestries. He was horrified by a little bronze Moore, a reclining figure of a woman, which he said was distorted.

The next time I saw Berenson was at I Tatti, his own home near Florence, and I was more polite to him than he had been to me as I admired his collection. I thought it very sad that so little was left of all the marvellous paintings that had passed through his hands. I begged him to visit me in Venice and promised to put sheets over all my paintings, if that would be an inducement for him to come. He asked me to whom I was going to leave my collection when I died, and though he was already eighty-five at that time, he looked at me with horror when I replied, 'To you, Mr Berenson.'

As a result of all the publicity, I was plagued by everyone who wanted to sell me something and I couldn't come down into the lobby of the hotel where I was staying without being accosted by innumerable people. I asked Vittorio Carrain, a young friend, who was one of the owners of the Angelo restaurant, to protect me. As a result, he became my secretary and worked with me for years. He was intellectual, musical and very knowledgeable, and also served me as a key to the life of Venice, as I never read any newspapers. He loved the atmosphere I lived in and was exceedingly kind and a devoted friend, and a great help when we made exhibitions and catalogues.

I requested Ingeborg Eichmann, a Sudeten art historian, to give a lecture in my pavilion to explain the various trends in art. So many people came to the first lecture, on Cubism and abstract art, that we had to call

123

off the second lecture, on Surrealism, in order to save the pictures from damage. They had all just been marvellously cleaned and refreshed by a Venetian painter called Celeghin, a charming man with enormous mustachios.

I used to go myself to the Biennale every few days and take my dogs with me. They were very well treated by a restaurant at the entrance called the Paradiso, and always given ice-cream on their way in. Therefore whenever I asked them if they wished to accompany me to the Biennale, they wagged their tails and jumped with joy. They were the only dogs admitted to the exhibition, and when they were lost in this labyrinth I always found them in the Picasso exhibition; which proves how valuable their education had been at Art of This Century, where they had accompanied me every day.

At the end of the Biennale, the question arose of what to do with the pictures. I had taken it for granted that if the Biennale had brought them to Europe, paying all the expenses, at least that they would be allowed to remain in Italy. But this was not the case. They had been brought in on a temporary permit and had to go out again. For several months I hesitated about what to do. I was expected to pay three per cent duty for importing them permanently into Italy. So I decided they would have to be taken out and brought back again at a lower valuation.

In the meantime the museum of Turin asked me to exhibit them there. I was delighted, but at the last minute, the day before the collection was to leave for Turin, the authorities of that city decided against showing anything so modern. A well known critic, Dr Ragghianti, then asked me if I would show the collection in Florence, in the Strozzina, the cellar of the

Strozzi Palace, which he was about to turn into a modern art gallery. He wanted to have my collection to inaugurate it, and made an excellent catalogue, which has been the basis ever since for my Italian one. When I arrived in Florence I was shocked by the lack of space in the Strozzina and by some dreadful screens that resembled shower curtains, which had been set up to make more space. Dr Ragghianti was very agreeable about removing these horrors, and accepted my proposal to give three different expositions. The first one was of Cubist and abstract art, the second Surrealist and the third dedicated to the young painters. This idea was very successful and permitted me to make three visits to Florence, all of which I enjoyed immensely, staying with my friend Roloff Beny. We had a very social life, and here I met a charming lady poetess from Dublin, New Hampshire, called Elise Cabbot. She was amazed by the number of my paintings shown in Florence and said, 'How did Peggy ever have time to paint them all?'

After this, I was invited to exhibit in Milan in the Palazzo Reale. Here there was no space problem. I have never had so many rooms at my disposal before or since. This show was such a great success that the catalogues had to be hired out while new ones were being printed. Francesco Flora wrote the preface to the catalogue and the show was given for the benefit of the Associazione Artisti d'Italia, as a result of which all the debts of this association were paid off.

When the collection came back from Florence the problem again arose of what to do with it. I had reached no settlement with the authorities in Rome, though I had offered the whole collection to Venice on

my death, if the Italian government would waive the duty they were claiming. But the old fogies in the Ministry of Foreign Affairs were adamant and would not let me off. The pictures in the meantime were housed in the modern museum in Venice, the Ca' Pesaro, a beautiful seventeenth-century building designed by Longhena, where Dr Perrocco, its curator, kept them for me. I was allowed to borrow a few at a time, but not too many.

A year after the Biennale exhibition Dr Lorenzetti, the director of the Ca' Pesaro, had asked me to make an American exhibition in two small rooms. Poor man, I am sure he was only doing his duty, as he must have hated modern art a thousand times more even than Pallucchini did.

At this same time, at the request of Michael Combe Martin, who was director of the British Institute, which was in the beautiful Palazzo Sagredo, I made a show of British painters there, so the pictures did manage to be seen.

PALAZZO VENIER DEI LEONI

PALAZZO VENIER DEI LEONI

Finally, in 1949, Flavia Paulon, secretary of Count Zorzi, found me a lovely abode. It was an unfinished palace on the Grand Canal, started in 1748 by the Veniers, a famous Venetian family who had given two doges to Venice and who were alleged to have kept lions in their garden. The front of the palace bore eighteen lions' heads, which may be the reason for the name given to it: Venier dei Leoni. It stands opposite the Prefettura, the palace of the Prefect of the Veneto.

The palace was all built in white stone and was covered with vines; 'All' is saying a lot, as the building never exceeded one floor, and in Venice is called 'the palazzo non compiuto', the 'unfinished palace'. It had the widest space of any palace on the Grand Canal, and also had the advantage of not being regarded as a national monument, which things are sacred in Venice and cannot be altered. It was therefore perfect for the pictures. At the front entrance there was a lovely court-yard with steps going down to the Grand Canal, and at the back one of the largest gardens in Venice, with very old trees. The top of the palace formed a flat roof, perfect for sun-bathing. I naturally took advantage of this, but was rather worried about the reaction of the Prefect, my *vis-à-vis*. However, he merely said, 'When I see Mrs Guggenheim sun-bathing on the roof, I know the spring has come.'

Signora Paulon got her husband to do up the place for me. Actually, it was not in very bad shape, though it had changed tenants very often since 1938. Before that, in 1910, Louisa, Marchesa Casati, a poetess, had lived in one of the wings, giving fantastic Diaghileff parties and keeping leopards instead of lions in the garden. In 1938, the Viscountess Castlerosse bought the house and spent a fortune doing over what was then practically a ruin. (I believe the Marchesa Casati barely had a roof over her head.) Lady Castlerosse installed six marble bathrooms and beautiful mosaic floors. Her taste was not the same as mine, and I had to scrape off all the Liberty stucchi from the walls. After the first year Lady Castlerosse lent the palace to Douglas Fairbanks jnr., and then three armies of occupation, German, British and American, lived in it in turn.

In the autumn of 1949, I made an exhibition of more or less recent sculpture in the garden, and Professor Giuseppe Marchiori, a well-known critic, wrote the introduction to the catalogue. We exhibited an Arp, a Brancusi, a Calder mobile, three Giacomettis, a Lipchitz, a Moore, a Pevsner, a David Hare, from my collection, and a Mirko, Consagra, Salvatore and two Vianis, which we borrowed from the artists. There was also a Marino Marini, which I bought from him in Milan. I went to borrow one for the sculpture show, but ended up by buying the only thing available. It was a statue of a horse and rider, the latter with his arms spread way out in ecstasy, and to emphasize this, Marino had added a phallus in full erection. But when he had it cast in bronze for me he had the phallus made separately, so that it could be screwed in and out at leisure. Marino placed the sculpture in my courtyard on the Grand

Canal, opposite the Prefettura, and named it the 'Angel of the Citadel'. Herbert Read said the statue was a challenge to the Prefect. The best view of it was to be seen in profile from my sitting-room window. Often, peaking through it, I watched the visitors' reaction to the statue.

When the nuns came to be blessed by the Patriarch, who on special holy days, went by my house in a motor-boat, I detached the phallus of the horseman and hid it in a drawer. I also did this on certain days when I had to receive stuffy visitors, but occasionally I forgot, and when confronted with this phallus found myself in great embarrassment. The only thing to do in such cases was to ignore it. In Venice a legend spread that I had several phalluses of different sizes, like spare parts, which I used on different occasions.

The sculpture show was supposed to be held in the garden, but because Viani had brought two works in plaster they had to be exhibited in the house. So many people came wandering into all our bedrooms that we had to cordon off the exhibition. I had a house-guest, Philip Lasalle, staying with me at the time, who perpetually forgot that there was an exhibition and often found himself in the midst of strangers in his pyjamas in the garden.

One of my Giacometti statues that I wanted to place in this show got stopped in the customs at Padua on its way from Milan. We went to fetch it in my open car. It was a beautiful thin figure without a head. We brought her back to Venice along the autostrada at great speed. Everyone who saw her must have thought she was a decapitated corpse. She was in very bad condition, so with the help of Consagra, a sculptor whom I

knew, I got her back to her normal state and had her cast in bronze. But when the original one saw her new bronze sister, she was so scornful of her, and rightly so, as her own beauty far exceeded the other, that she remained intact ever since.

In 1950, I was asked if I would lend all my Pollocks (there were still twenty-three), to an art organization to give a show. They were supposed to get a room from the local authorities, but as they did not succeed, I came to their rescue and got old Dr Lorenzetti to lend us the Sala Napoleonica in the Correr Museum, opposite San Marco cathedral. All that the organization did was to make a catalogue, for which I wrote an introduction and Bruno Alfieri a preface. When it came to fetching the pictures and hanging them, Vittorio Carrain and I had to do everything. The climax came when a terrible Greenwich Village-looking poster was put up, and when the catalogues gave out, they refused to print any more. I was so enraged that I took over the show, which really was mine, by all rights, and made a new catalogue, omitting Alfieri's article on Pollock. Thousands of people saw this exhibition, as it was in a room through which one had to pass in order to get into the Correr Museum. It was always lit at night, and I remember the extreme joy I had sitting in the Piazza San Marco beholding the Pollocks glowing through the open windows of the Museum, and then going out on the balcony of the gallery to see San Marco in front of me, knowing that the Pollocks were behind me. It seemed to place Pollock historically where he belonged as one of the greatest painters of our time, who had every right to be exhibited in this wonderful setting. All the young painters were very much influenced by this show.

Encouraged by the Pollock exhibition, I got Dr Lorenzetti to lend me the Sala degli Specchi in the Palazzo Giustinian, the headquarters of the Biennale, for an exhibition I wanted to give Jean Helion, my son-in-law. Everything went wrong from beginning to end It was an ill-fated show. First of all, Christian Zervos who edits *Cahiers d'Art*, took ages to write the introduction to the catalogue. When it arrived, it was much too long and I had to cut it and have it translated, and then Helion was displeased by my cutting it. The pictures got stuck in the customs, as always happens in Italy, and we nearly had to call the show off. Finally, Vittorio Carrain overcame all these difficulties, only to find new ones creeping up. Two days before the show was to open, the brocade that covered the walls of the Sala degli Specchi was removed by the person who owned it, and we were forced to replace it with some sacking. Then, as though the gods were against us, a terrible storm came and rain dripped from the crimson banner we had placed in the street to announce the show and ruined the dress of a girl passing beneath it. After that, the wind blew down the banner altogether. It really was a triumph that we held the exhibition at all.

Helion showed three periods of his work, his early naturalistic paintings, his abstract period, and his new period, which began in 1943, portraying men with umbrellas, nudes, men with newspapers, and *natures mortes* with bread. People were very much interested to see these various transitions and how he was getting around to complete realism, which he now does.

As a result of all our troubles in connection with this show, I decided never again to do anything with works from abroad, or ever again to ask the authorities for a

gallery. My own troubles with the customs had not been solved, and Dr Sandberg, of the Stedelijk Museum, suggested taking my collection to Amsterdam for an exhibition, and then sending it on to the Brussels Palais des Beaux Arts and to the Zurich Kunsthaus, thus giving me a proper excuse to reintroduce it into Italy. This was done very successfully. After the three shows, the pictures were brought back from Zurich and finally I was allowed to pay the least possible amount of duty.

I was so happy to have my collection back again, and at last to be able to hang it in my palazzo; but the next problem was one of space. I got three architects in Milan, Belgioioso, Peressutti and Rogers, to draw up plans to make a pent-house on my roof. They were very much under the influence of Le Corbusier, and thought of an arrangement that reminded one of him, namely a two-story gallery elevated from my roof on pillars twenty feet high. The front was to resemble the Doge's Palace, and in their minds they conceived something that they thought would be a link between the past and the present. I found it very ugly and I was certain the Belle Arti of Venice, the authority that controls all rebuilding in the city, would never have allowed it to be built. It would have cost sixty thousand dollars, only a bit less than I paid for the whole palazzo, and I could not afford it. In fact, I was only able to buy the palazzo because Bernard Reis broke one of my trusts for me. Peressutti was terribly disappointed, and asked me if I could not sell a picture in order to find the money. Had I liked the scheme, and had prices been what they are today, I could easily have parted with one painting to have built this museum.

Finally, in order to create space, I began turning all

the downstairs rooms, where the servants lived and the laundry was done, into galleries. Some of these rooms had been used as studios, which I had lent to various artists. Matta helped me transform the enormous laundry into a beautiful gallery, and then one by one the other rooms followed suit, till finally the servants got pushed into smaller quarters and the laundry had to be done in a basin at the entrance to the waterfront.

Since 1952, I had been sponsoring a young Italian painter from Feltre, whom Bill Congdon had asked me to help. His name was Tancredi Parmeggiani, but he only used his Christian name, dropping the one that so much resembled the cheese. I promised him seventy-five dollars a month in exchange for two gouaches. His first ones were very geometrical and resembled van Doesburg's (which greatly pleased Nellie, his wife), but gradually he evoked a Pollock style, and then finally his own. He is what is called in Italy a Spazialista, a spatial artist. His gouaches soon filled my house. They were so delicate and airy, and were very easy to sell after the first year, when I had given them away as presents. As there was no room other than a guest-room to show and sell them in, they had to be piled up on a bed. When James Sweeney came to Venice and saw them, he at once said, 'Get that boy canvas and paints and let him expand, he needs space.' I did as I was told, and then my spatial problem grew to such an extent that I no longer knew where to show the canvases. Tancredi had one of the studios in the cellar for several years, but it was a great relief when he finally left, as he used to drive the servants crazy by walking all over the house with his feet covered in paint of every conceivable colour. When at last he left, it took four days to remove this mess from the floor

of his studio. This room has now become a Pollock museum, and Tancredi's paintings are sold in the room that used to be the laundry.

My second protégé was Edmondo Bacci, a very lyrical painter in his mid-forties, whose work was inspired by Kandinsky. He had a very organized way of life and with him everything went calmly and successfully. Tancredi, on the other hand, who was in his early thirties, was madly temperamental and perpetually made rows. Often he removed all his paintings, only to bring them back in a few days. As I gave him the money (keeping no commission other than the pictures he gave me, which in turn I gave to museums) he threw it all away, only to come back for more. When I tried to give him a weekly allowance he went around Venice saying he would sue me for having ruined his career. Bacci and Tancredi are the two painters in Italy whose works give me most pleasure, and I have my private apartments filled with them. I also admire Vedova's work and own three of his paintings.

Apart from this, and opening my house to the public three afternoons a week, I have not done much in Italy. Santomaso was madly disappointed, as he thought I was about to become a new dynamic and cultural centre for Italian art. But I was so uninspired by what I found in Italy that little by little I lost interest. The painting in the Biennale gets worse every year. Everybody just copies the people who did interesting things twenty years ago, and so it goes on down the line, getting more and more stereotyped and more and more boring. I have continued buying whenever possible, but infinitely prefer contemporary sculpture to painting.

Since my collection has been opened to the public,

people come from all over the world to see it, and as I also hold a salon for intellectuals, a great confusion arises. Anyone is welcome to visit the gallery on public days, but some people, not understanding this, think that I should be included as a sight. I get phone calls from many persons whom I do not know, who begin by saying, 'You don't know me, but I once met your sister Hazel in California,' or, 'Your friend Paul Bowles told me to phone you,' or, 'We have just arrived in Venice and have a letter of introduction to you, and would like to invite you to lunch or dinner or a drink.' On one occasion a young American, in Italy on a Guggenheim musical fellowship, even wrote and asked if I had a piano, as he would like to come and practise on it. I was happy to be able to say I hadn't got one. I would never dare phone a stranger on such flimsy pretences. If I had a letter of introduction, I would send it round and wait to be invited. People don't know how to behave any more. Oh, for the good old days, when they still had manners!

My salon is most informal, provided you have been invited, but my museum days are strictly for art lovers. All my personal guests are requested to write in my guest-book, and if they are poets or artists they may add a poem or a drawing, which is more than welcome.

When Mrs Clare Boothe Luce, whom I had met occasionally at Consular parties, was our Ambassador in Italy, I invited her to come and see my collection, which she did very late one night, followed by a train of people. I felt that none of them were much interested in art, but Mrs Luce, as usual, was very polite and charming, and of course marvellously dressed, looking younger

and more glamorous than ever. She seemed to like best my daughter, Pegeen's, paintings, though when I made the observation that the people in Pegeen's paintings, strangely enough, never seem to be engaged in any conversation with each other, all going their own ways, Mrs Luce replied, 'Maybe they have nothing to say.' When Mrs Luce went into my dining-room she encountered three young Italian painters, Dova, Tancredi and Crippa. In her true ambassadorial manner, she asked them whom they considered the best painter in Italy. Each of the three at once answered, 'I'.

Mrs Luce complained that my corridors were not sufficiently lit to view the paintings properly. I must admit she was quite right, and I afterwards installed strong fluorescent lights for which idea I am very grateful to Mrs Luce. This suggestion gave me occasion to make a good Italian pun, as 'la Luce' (as Mrs Luce was called in Italy) thus brought *'la luce'* to my house, *'luce'* in Italian meaning light.

Count Zorzi, who ran the Biennale review, and who now, to my sorrow, is dead, was one of the few remaining grand seigneurs of Venice. He was, quite fittingly, the descendent of a doge, and one of the few people in Venice with elegant manners and a sense of humour. The Biennale always consulted him about protocol. But that wasn't the only thing he knew about. He ran their bi-monthly review extremely well, and always encouraged me to write for it. He wanted an article on Pollock, but I never felt up to it. But I did write one, which he also asked for, about how I became a collector. Then I wrote one on my painter-daughter, Pegeen, and one on Bill Congdon. In this article I claimed that he was the first painter since Turner who had understood

the soul of Venice, and in the article on Pegeen I expounded Herbert Read's theory that she has remained as fresh and pure in her painting, and still brings the same magical, innocent touch to her work, as she did at the age of eleven.

In the article on how I started to be a collector, I related a story about a woman who went around an art show grumbling bitterly all the time. I approached her and asked why she bothered to come and look at painting that seemed so much to displease her. She replied that she wished to learn what modern art was all about. I warned her how dangerous it was to do so, as she might become an addict.

After my show at the Biennale, they were perpetually asking me to lend them pictures for their successive exhibitions. In the beginning I complied with their requests, but later there were so many demands from everyone that when my house was opened to the public it became impossible to lend any more. Pallucchini took offence at this and wrote me a very unpleasant letter, scolding me and telling me how ungrateful I was for all the Biennale had done for me. I wrote back and said, on the contrary, they should be grateful to me for having lent them my collection, which turned out to be the most popular show in the Biennale of 1948, and that therefore we were quits. He was so infuriated by this that he had my name withdrawn from the list of people who were invited to the opening of the Biennale, and in 1952 I had to accept Santomaso's kind offer of his invitation in order to get into the opening.

When Count Zorzi died, Pallucchini wrote him a beautiful obituary in the Biennale magazine. I was so moved by this that I felt it incumbent upon me to write

to Pallucchini telling him so, and thanking him. This brought about our reconciliation, and now my name has been put back on the invitation list.

At one time I considered buying the United States pavilion at the Biennale, which belonged to the Grand Central Art Galleries, who wished to part with it for about twenty thousand dollars. But I felt it would have been an awful responsibility, and also one that I could not afford. It would have meant going to New York every two years to choose the shows, and then incurring all the expense of transport and insurance. It obviously was a museum's job, if not a government one. All the other foreign pavilions of the Biennale are under the auspices of organizations sponsored or supported by their governments. But we in the United States had no government subsidy for the Biennale. Luckily, in 1954, the Museum of Modern Art bought the pavilion, which was more fitting.

In 1950, Alfred Frankfurter, editor of *Art News*, arranged an American show in this pavilion, in which Pollock was represented by three paintings. By far the best in the whole Biennale was one of his called 'N I 1948', owned by the Museum of Modern Art. This magnificent painting, which several years later was one of the few to suffer in the Museum fire, stood out beyond everything in the whole Biennale, even though there were shows of the Douanier Rousseau, Matisse and Kandinsky. I remember at the time my infinite surprise at having been convinced of this fact, because it was always difficult for me to accept Pollock's greatness.

In 1950 also, the Biennale made a very small mixed sculpture exhibition in a ridiculously inadequate space, not in the main hall of the Italian pavilion, where it

should have been held, but in an outside one. The exhibitors were Arp, Zadkin and Laurens. Giacometti refused to exhibit because Laurens had such a bad salle. Arp had been warned that he was very badly shown, and when he arrived in the central hall, where there was a Viani show, he said with joy, 'Oh, I haven't such a bad place at all.'

In 1954 Arp had a beautiful show at the Biennale. So did Max Ernst. They each received the most important prize. On this occasion Max came to my home and wrote in my guest-book: 'An old friend is come back forever and ever and ever', and so finally peace was made.

The prizes given at the Biennale always cause great excitement. A lot of politics are involved and no one is ever pleased. The four most important prizes, two for painting and two for sculpture, are given by the Presidenza del Consiglio dei Ministri, which gives two for two million lire each, and by the Commune of Venice, which gives two for one million five hundred thousand lire each. Innumerable other small prizes are given by all sorts of people and business firms, not only in Venice but all over Italy. Amongst these there is one given by the Angelo restaurant, which belongs to my ex-secretary, Vittorio. The Angelo is much frequented by artists and the walls are covered with contemporary paintings, an idea started by Vittorio's brother, Renato, who died in a car accident two years ago. He also catered for rugby players as well as artists, and it was very odd to see these two completely different elements equally at home in this restaurant, which serves delicious food and where I ate daily for years before I found my palazzo.

In 1956, the Museum of Modern Art lent their

Biennale pavilion to the Chicago Art Institute, and Katherine Kuh, who was then a curator of the Institute, made an exhibition called 'The American Painters and the City'. Katherine came to my house to buy a Bacci, and was very much impressed with my two maids, whom she called my curators, who helped drag enormous canvases in and out. These two Italian country girls act as hostesses on Mondays, Wednesdays and Fridays, the days on which my house is open to the public. I usually hide on these occasions. Afterwards, they often relate to me what has happened during the course of the afternoon. Once they told me with great horror that a Cubist Braque had been pointed out to a group of students as a Picasso. I said, 'Why didn't you correct this?' and they replied, 'Oh no, we couldn't, because it was a professor'. Besides making my maids into curators, I have also taught my two gondoliers to be expert picture hangers.

One day, in 1948, when I was walking through the Campo Manin, I noticed a very exciting painting in the window of a little art gallery. My first reaction was to take it for a Pollock. I went in and met the artist, who turned out to be Allan Davie, a tall Scotsman with a red beard. He had a blonde, equally Scottish wife called Billie. I bought a painting at once and we became great friends. Later his father, a clergyman, wrote me the sweetest letter, thanking me for the interest I took in his son. Allan Davie developed his own style very quickly, and though his work was not bought by anyone except me for years, he is one of the best British painters. Now, like everyone else as good, he has finally been recognized in England and New York, where he has been a great success, though for years he had to support his wife and baby by making jewellery.

In 1950 I met Dr Eugene Colp, the curator of the museum of Tel Aviv. He asked me to lend him a large number of pictures to show there. At that time, my basement was stacked with the overflow of my collection, and as the cellar was very damp, I began giving away pictures, including Pollocks, in all directions, which, as I have already said, I now very much regret. My friend Bernard Reis said that instead of lending Dr Colp the pictures I should give them to him, so I gave him thirty-four, and later some more. Dr Colp was very much infatuated by me, and one day when he asked me what there was between us I replied, 'Nothing, except thirty-four paintings.'

My cellar was also stacked with all the paintings I had bought during Art of This Century shows, such as those of Baziotes, Motherwell, Still, Virginia Admiral, Pousette-Darte, Laurence Vail, Pegeen, Kenneth Scott, Janet Sobel, Rothko, Hirshfield and Gorky. In 1953, Walter Shaw and Jean Guerin, òld friends of mine, who lived in Bordighera, asked me to lend them all these paintings to make an American show there. It was under the auspices of the Commune, and therefore rather official. Cocteau wrote the introduction to the catalogue. I accepted, and went there with Laurence Vail and a friend of mine called Raoul. The luncheon that Walter and Jean gave for Cocteau and for us was very amusing, but the long-drawn-out official dinner party bored Raoul, and he left as soon as it was over. To my surprise, we were all three the guests of the city of Bordighera and were given three lovely rooms in a hotel. Raoul, who was only interested in motor cars (in one of which he was so soon after to meet his untimely death) never took much interest in art, but he was, as Herbert Read called

CONFESSIONS OF AN ART ADDICT

him, quite a 'philosopher'. Raoul always maintained that I would go down in history, which statement, though quite exaggerated, I found very touching.

I had a dog named Sir Herbert, after Mr Read (as he then was), though the dog was knighted by me long before Herbert. When I phoned Raoul to tell him about the real Herbert Read's knighthood he said, 'Do you mean the dog?' The same thing always happens in my home when Sir Herbert is my guest. The servants invariably ask, 'Do you mean the dog or the man?'

After I left New York, Pollock had a very unsuccessful show at Betty Parsons' gallery. A few months later my contract with Pollock expired, and he remained with Betty without a contract until 1952, when he went to Sidney Janis's gallery. Not being in New York, I had no idea what was happening, but soon I began to realize that little by little everything I had done for Pollock was being either minimized or completely forgotten. Catalogues and articles began to appear, ignoring me or speaking of me in inadequate terms, as in the case of Sam Hunter, now curator of the Minneapolis Museum, who referred to me in his introduction to a travelling Pollock show as Pollock's 'first dealer'. In the São Paolo catalogue and in the New York catalogue of the Museum of Modern Art, Sweeney's introduction to my first Pollock show was attributed to my uncle's museum (where I knew Pollock had merely worked as a carpenter). In the biographies in the São Paolo catalogue I was completely ignored. Everyone gave credit to the Fachetti studio in Paris for Pollock's first European show, ignoring the ones that were held in Venice by me, and one in Milan, for which I had lent my pictures. Worst of all was an article that appeared in *Time*

The Palazzo Venier dei Leoni

With Pevsner's construction

magazine, accusing Pollock of having followed up his success at the Biennale by coming to Europe to further his career by showing in the Correr Museum in Venice, and in Milan. Pollock was furious and wrote a letter to deny this, saying he had never left the United States. My name was not mentioned in the article, nor in Pollock's reply, and my great friend Truman Capote, who was very indignant, said someone should have written another letter with the true facts, but no one did. I complained to Alfred Barr and to Sam Hunter, and Barr did his best to straighten things out, but I was taking no chances, and when Pollock's pictures were shown in Rome, I was very careful to write all the facts to Carandente, assistant to the museum director. At least in Italy I wished to have things straight.

A few years ago Rudi Blesh, who had exhibited his paintings in Art of This Century, wrote a book about modern art called *Modern Art in U.S.A.* He knew all about my gallery and wrote the truth as he saw it, and as it was. I believe this made the book very unpopular amongst those who were pretending to have discovered Pollock. Some of the facts I referred to occurred before Pollock's death and gave me reason to believe that Pollock had been very ungrateful, so when in the summer of 1956 Lee Pollock arrived in France and phoned to ask if I would find her a room in Venice, I said that Venice was absolutely full up. A few days later, I received a cable from Clement Greenberg telling me to break the news of Pollock's death in a car accident to Lee Pollock, who was supposed to have been with me. Imagine how I felt. Maybe it would have been a fitting end to the Pollock cycle if Lee and I had been together at this moment. But we were not, and that is why.

Actually, when I went to Rome for the Pollock show in the Modern Art Museum in 1958, I was terribly moved, seeing all the early enormous canvases that for years I had dragged in and out and encouraged, if not forced, people to buy. It certainly had been the most interesting and important time of my life, since 1934, and I think by far my most honourable achievement.

At this point I must go back to certain events that occurred in 1948, in order to lead up to the Museum of Modern Art in Rome. After I accepted Count Zorzi's invitation to the Biennale, I went to Capri for the winter. In the spring, Italy was to have a general election, and everyone was terrified that it would go Communist and that Tito would immediately walk into Italy. The atmosphere in Capri was very hysterical and some of my friends made me so nervous that I began to regret my promise to the Biennale. I thought the collection was safer in storage in New York. However, I decided to consult the head of the United States Information Service (USIS) in Naples. He sent me on to Rome to Dr Morey, who was the cultural attaché at the United States Embassy. What a charming and distinguished man he was! He immediately reassured me so much (being convinced himself that Italy would not go Communist) that I decided to let the Biennale have my pictures. Not only that, he also sent me to Dr Palma Bucarelli, the director of the Modern Museum in Rome, to arrange to show my collection there, under the auspices of the United States Government, after the Biennale. Dr Palma Bucarelli accepted with joy, as the United States was to pay all the expenses. Unfortunately when the time came the Government had withdrawn a

greater part of the funds from the new budget of usis, and the project had to be relinquished.

CEYLON, INDIA AND VENICE AGAIN

CEYLON, INDIA AND VENICE AGAIN

In the fall of 1954, after Raoul's death, I decided to get out of Italy and try to think of something else. Paul Bowles had invited me to Ceylon, where he had bought a little island. It was the southern-most inhabited spot in the Indian Ocean, fantastically beautiful and luxuriant, with every conceivable flower and exotic plant from the east. The house resembled the Taj Mahal, as it was built in octagonal form. We all lived there together in separate rooms divided by curtains, we being Paul, his wife Jany, Ahmed, a young Arab primitive painter of great talent, and an Arab chauffeur, who seemed rather sad without the Jaguar car, which had been left behind in Tangiers, Paul's other home.

In order to get to the island one had to pick up one's skirts and wade through the Indian Ocean. There was no bridge or boat. The waves usually wet one's bottom, even though the distance one walked could be done in one minute and a half. It was terribly unpleasant to go about all day with a wet bottom, but there was no other way. The beauty of the surroundings made up for all the inconveniences, which were many. There was no water on the island and the servants had to carry it over on their heads. This made bathing, apart from sea-bathing, virtually impossible. But there was a raft just below the house and the swimming was superb. The beach opposite was skirted with coconut palms, and there were narrow fishing craft with beautiful Singalese fishermen riding

them astride. It was another dream world, so different from Venice.

As Ceylon was such a small island, I was received with enthusiasm and written up in the papers as a great art authority and asked to broadcast. I was even consulted by the wife of the chief of police, who begged me to tell her if her twelve-year-old son should be encouraged to paint. His father very much disapproved of his artistic child's pursuits, which were fostered by the adoring mother. Actually, the child was an infant prodigy, and I had to admit it to the father, with the reservation that often children who began painting well lose all their freshness when they grow up.

Reading from my diary I find the following entry: 'Yesterday I was invited to go and see the paintings of a child genius, son of the chief of police. His father does not want him to paint, except as a hobby, the mother is fostering the child's genius. An angelic little creature of twelve, who showed me all his pets, dogs, puppies and white mice. His paintings are as mature as a man of twenty-five. He has an extraordinary talent amounting to genius. His style is not formed, sometimes it resembles Matisse or Bonnard, but he has great force and sense of colour and design. A direct, simple and pure approach, and at the same time quite sophisticated. His mother was a beautifully dressed little elegant Singalese, with oriental jewellery and wearing an occidentalized sari. The house was a little gem, all opening on to lovely cinnamon gardens. My infant prodigy had exquisite hands. He showed me all his art books, Egyptian, Japanese, Dufy, Picasso, etc. The child had wonderful taste and perception in pointing out details. The mother spends all her money on his paints and art books.

'There was another infant prodigy, a cellist, a protégé of Casals. He belonged to a very distinguished family and his uncle, Darangale, is one of the best painters of Ceylon, but I fear too much influenced by Tchelichef. This infant prodigy was much older, about sixteen, and already well known as a cellist. He also had an adoring mother, who lived only to further his career. But she seemed as worried as the wife of the chief of police. Neither of these ladies seemed to be entirely convinced that they were doing the right thing.'

After five weeks in Ceylon, I set off alone for India. My trip was planned by Thakore Saheb, the Indian Ambassador in Colombo. He had formerly been in Washington and was married to the sister of the Maharajah of Mysore. He must have had a very exaggerated idea about the speed of American travellers, which I grant can be rather racy, as the itinerary he prepared for me would have killed a far stronger person than I was. I had to cut out about half of it, though I managed to visit over twenty cities in forty-eight days. In Colombo I was told by a journalist not to miss the paintings of Jaminy Roy, in Calcutta. When I got to Mysore, where I went to visit the Maharajah, I went to the Art Museum. Faced with a painting that resembled a Brauner, my mind began to wander and I tried to remember the name of the painter whom I was supposed to look up in Calcutta. I was very upset because I did not succeed. I thought I must send a wire to the person in Colombo who had told me about him. Suddenly I looked up at the painting I was standing in front of, and realized that it was a Jaminy Roy.

When I got to Calcutta the publicity agent of the West Bengal Government, to whom I had a letter of

introduction from the Indian Ambassador, took me, upon my request, to visit Jaminy Roy, to whom he presented me as an art critic. In my diary I find the following entry: 'Went to visit Jaminy Roy, a saintly man of sixty. Lives in a beautiful white modern house, where he shows his paintings. They are all mythological subjects, even the Christian ones. He has exhibited in New York and London, but has never left India.'

Jaminy Roy paints a lot on a woven papyrus, but I bought a picture for seventy-five rupees (about five guineas) which was on paper, as it was easier to pack. The picture depicts the abduction of Siva by Ravana. The demon King Jataya wanted to stop Ravana, a fight ensued and Jataya, the valiant bird, was killed. This is an episode from Ramayana, the great Hindu mythology. Jaminy Roy had copied a few European painters from reproductions. One was Campigli and another was Van Gogh. His own work resembled Victor Brauner's, except that all his eyes are shaped like little boats or almonds. He has a primitive quality, like the Arab Ahmed. He does not approve of three-dimensional painting. His is quite flat. I felt he was a wise man and quite unspoilt.

When I got to New Delhi, exhausted by all my travels, trying to keep up with the itinerary of Thakore Saheb, I was rescued by Paxton Haddow, a lovely girl in the American Embassy, who worked for USIS. She invited me to live with her in a beautiful house, and thus for a while I forgot I was a tourist.

Pax drove me to Chandigarh, a city which is to take the place of Lahore, the former capital of the Punjab, which belongs to Pakistan, since the division of India. The following entry is in my diary: 'Went . . . to Chandigarh, where we arrived a few hours after the

Prime Minister had held the official opening of the supreme court, the masterpiece of Le Corbusier, a very fine monument, much resembling his apartment house in Marseilles, but of course much less domestic. The whole town of Chandigarh, laid out by Le Corbusier, is an amazing example of modern town planning, all built within his theory of Man's proportions. The head, the body, the arms must all be represented approximately. It was amazing to see Chandigarh after seeing Fatehpur-Sikri, the dead city near Agra. There are twenty-six sectors in all, with huge highways for fast traffic and roads for pedestrians . . . Few sectors are finished, but those which are contain houses all alike, in straight rows, to be rented by government officials at ten per cent of their salaries. So everybody knows by your house-rent what your salary is. All the people who are judges live in one row, etc., down to the coolies, who have their own houses. As a venture, this is stupendous, but the other buildings, designed by Maxwell Fry and Jane Drew, are not so nice. Le Corbusier designed some of the official buildings, engineering college, schools (each sector is to have one), hospital, printing office, etc. There are few trees, and the whole effect so far is very desert-like and monotonous. In ten or twenty years it will be interesting to see. Now, everything is makeshift, the schools being used for assembly halls, local dispensaries for hospitals, etc.

'A very charming woman, wife of a judge, accompanied us, and though she knew much less than Pax, who had been there once before, she knew more of the practical side of living in Chandigarh. She had chosen a house that she already regretted, as a huge building was going up opposite, though she had especially chosen the house

for its privacy. She lamented her dining-room, which served as a corridor. There was no portico over the entrance to protect her from the rain, which is devastating in Chandigarh. Her garage was behind the house, as were the servant's quarters; all very bad for the monsoon time, which causes floods. Her house, being one of the first to be built, was already out of date. The new ones had benefited by all the mistakes made in building the others, and were much nicer, as we saw for ourselves.

'We stayed in a Le Corbusier hotel. It was quite comfortable. Le Corbusier had made lattice-work cement walls everywhere to keep out the sun and let in the wind. This idea, though seemingly his invention, is an old Indian custom, so everyone is happy. The city is not beautiful, and never will be, because the houses are too regular, similar and uninspired. Anyhow, the idea is to raise the standard of living of the poor. It is quite socialistic. We saw one cinema in one sector that is finished. This sector resembled a town in the United States . . . The whole enterprise must give great satisfaction to Le Corbusier, who is the only person in the whole world ever entrusted with such a commission. In his office there is a plan on the wall, which you are supposed to view before you see the town. The workmen of Chandigarh have been honoured by having the streets lined with poles bearing the colourful bowls which carry earth and cement, the symbols of their work. The worst houses looked like women's knitting or embroidery. There were one or two rows of very handsome houses, but nothing really wonderful or stately. However, the enterprise was not supposed to be anything else. Too bad. It could have been much better, even within these limits.'

Modern art in India was very disappointing, as it

was in Ceylon, where George Keytes was considered the best modern painter. He decorated temples in semi-realistic style with Buddhist myths as subjects. I could find nothing to buy besides my Jaminy Roy, except one very lovely primitive painting I saw in an all-Indian show in New Delhi. This depicted a village scene of peasants seated at night around a table. It had tremendous atmosphere and, though it was not at all realistic, gave one a great sense of Indian life. I wished to buy it, but when Pax went with the money she was just too late, as Nehru had given it as a present to Nasser.

What I lost in painting I made up for in ear-rings, coming home with a great many bought all over India, and even some from Tibet. These I found in Darjeeling, where I went to look for Lhasa terriers, endeavouring to put an end to the in-breeding of my numerous dog family. I went to visit Tenzing Norkey, the sherpa who climbed Mount Everest with Hillary. Tenzing had six Lhasas who walked with him daily in the Himalayas, but he would not part with any of them.

Princess Pignatelli once said to me, 'If you would only throw all those awful pictures into the Grand Canal, you would have the most beautiful house in Venice'. And so it was considered. But no Venetian approved of my modern décor. However, I had to have a suitable modern décor for the collection, which was exhibited all over the house for lack of space. In place of a Venetian glass chandelier, I hung a Calder mobile, made out of broken glass and china that might have come out of a garbage pail. I had sofas and chairs covered in white plastic that could be washed every morning, as my large family of dogs felt most at home in the best seats. (My two

157

darling Lhasa terriers had mated with a gentleman dog specially brought for this purpose from America by Mrs Bernard Reis, and had produced fifty-seven puppies in my home. About six usually remain in residence.) Over the sofas I placed black-and-white striped fur rugs, which the dogs adore to lick. This was also un-Venetian.

Most Venetian, and at the same time un-Venetian, is a *forcole*, or gondolier's oar-rest, which Alfred Barr presented me with for my garden. Those who don't know what it is admire it as a wonderful piece of modern sculpture, which is just what Alfred intended.

Originally the entire house was open to the public on museum days. My poor guests—how they suffered! I remember once the painter, Matta, locking himself up in his room in order to take a siesta. The lock was so seldom used that we had to get a locksmith to release him. I did not even have the privacy of my own bedroom, as it contained my Calder bed, which, strangely enough, against my turquoise walls looked as though it had been made for its ultimate destination—Venice. There is also a painting by Francis Bacon, the only one of his I have ever seen that didn't frighten me. It depicts a very sympathetic ape seated on a chest, guarding a treasure; the background is all done in fuchsia-coloured pastel, which goes admirably with my turquoise walls, and with a curtain made out of an Indian sari and a marabou bedcover of the same colour. The rest of the walls are decorated by my collection of ear-rings, a hundred pairs or more, collected from all over the world. In addition to this, the room has Venetian mirrors and Laurence Vail's decorated bottles and Cornell's Surrealist 'objects'. Everything combined makes a fantastic atmosphere.

It was difficult to exclude the public from all this, but in the end I had to. Now, only friends, or visitors who specially ask to see it, are allowed to. My dining-room, hung with Cubist paintings, has to be open to the public. This room has fifteenth-century Venetian furniture which I bought in Venice years ago, and brought back to its original home, after having lived with it in the South of France, Paris and Sussex, my previous homes. The Cubist pictures look admirable with the old furniture.

When all the spatial possibilities of the palazzo were exhausted I decided to build a pavilion in the garden. At least there was plenty of room. Next came the tree problem. In Venice no one is allowed to cut down trees, not even their own. I therefore decided to build along a wall which I shared with my neighbours, the American Consulate, the State Department having bought this property a few years previously. (This turned out to be a blessing in disguise, as I have been guarded by soldiers night and day ever since.) This was the only part of the garden where there were no trees. I now required the permission of the State Department. It seemed very odd, living in Italy, to need this. However, it was no problem. Permission was soon granted. After that, I had to have the permission of the Belle Arti. My architect submitted our plans to the Commune of Venice who, thinking they were pleasing the American Consul, never presented the plans, but hid them in a drawer and hung me up all winter. In the end I had to write to the Mayor of Venice to have them released. Finally the Commission of the Belle Arti came to inspect my garden and passed the project.

During this time I had changed my plans several times. At first, I had wished to build a pavilion that

would have resembled a painting by De Chirico, called 'Melancholy and Mystery of a Street', but Vittorio Carrain warned me that my building with all its arches might turn out to look too fascist. My friend Martyn Coleman, who always gives me the best advice in matters of taste, told me to make a loggia outside the building. I copied as closely as possible the wing of the Palladian villa Emo at Fanzole. However, my loggia had to be much smaller, as there was only room for six arches, instead of eleven. The Belle Arti consented to this plan, with the exception of one vital point: a lady architect called Trincanato insisted on preserving intact a little lost corner of the garden and would not allow this very necessary space to be used. Therefore I could not join up the new wing with my house, which I should have done in order to make a real *barchessa* (as such wings were called in Veneto, where they were and still are, used for storing grain and hay). So my architect, Passero, had to modify the plans. There was no time to waste. The Biennale was to open in two months, and my *barchessa* had to be finished by then.

The opening of the Biennale is of great importance in Venice. The entire art world comes for a week—not only all the organizers of the different exhibitions, and the architects of the new pavilions, but all the artists who are invited, or failing that, the ones who can afford to, as well as many others. It is a big fair, and a tremendous amount of salesmanship goes on. All the art critics come too, and all the gallery owners who have any exhibition on. As I am a collector, and as I made a point, as long as I could, of buying something at the Biennale, everyone focuses their attention on me. Also the art collectors come, and all this means innumerable

parties continuously for a whole week. I usually give a very big cocktail party in my garden, so the *barchessa* had to be finished in time, and it was. But not only had the *barchessa* to be finished, but the whole garden, which I had let grow wild for ten years, had to be put in order. However, this was finally accomplished too, and the garden looked larger than before, which surprised everyone. In the *barchessa* I made an exhibition of all the younger artists' work that I had bought in the last few years. It really looked lovely, and I called it 'my *Biennale*'.

In the fall the builder, against the wishes of the architect, took matters in his own hands and said we could finish the *barchessa* as it had been originally planned without getting the permission of the Belle Arti. We persuaded the architect to proceed, and then disregarding the architect Trincanato's admonition, built the second half of the pavilion, which was much prettier than the first, on her sacred spot, leaving just a fragment of the garden in the very background. This time we connected the *barchessa* with the palazzo, and it was an immense improvement.

The workmen had been very nice all the time they worked in the garden, in spite of the fact that they had completely upset our life. We were in perpetual danger of falling into pits, being covered in dust, or being deafened by the noise of machines. A fifteenth-century well came to light during the excavations, as did also part of a house of the last century. Wanting to show my appreciation of the workmen, I asked the builder what I should do for them, and he said that at the termination of the building operations I should give them what is called a *granzega*, meaning a dinner party. It was a great

success, held in June in the garden of my favourite restaurant near the Accademia. We were eighteen to twenty people, and the architect's wife and I were the only women present. We drank a lot and got very gay. I moved from one guest to another in order to talk to them all. They sang songs and one played a mandolin. Suddenly I remembered my guest-book, and sent home for it. When it came, they all signed their names, and the partner of the builder turned out to be a poet and wrote a lovely poem for me, in which he called me the Lioness, in honour of the name of my palazzo. The architect, Passero, made a lovely drawing of the *barchessa*. The next morning, when I woke and looked in my guest-book, I found my addition to all my guests' signatures. The following words were written in a very wobbly handwriting: 'The nicest night of my life in Venice, 1948–58, Peggy G.'

I gave a second *granzega* in the fall, at the termination of the second building. It was held in the same restaurant but because of the season was not in the garden. Maybe for this reason it was not so pleasant. In fact, it was a complete let-down. I presume one cannot repeat such a marvellous soirée. But if the second party was not such a success, the second building definitely was. The *barchessa* was now large enough to permit me to place all my Surrealist paintings and sculptures in it. I removed them from a very overcrowded corridor in my palazzo, and also took this occasion to rehang everything in my home, as well as finally deciding not to admit the public to my library and sitting-room any more. I painted both rooms white, instead of the dirty dark blue I had suffered for ten years, and felt that a new life was commencing.

NEW YORK REVISITED

NEW YORK REVISITED

I had many times put off returning to America, where I had not been for twelve years. Instead I had been to Sicily, Malta, Cyprus, India, Ceylon, Lebanon, Syria, Greece, Corfu, Turkey, Ireland, England, Holland, Belgium, Yugoslavia, Austria, France, Switzerland, Germany, Spain and Tangiers. I had always said I would return to New York for the opening of my Uncle Solomon's museum, When my uncle died, several years ago, his nephew, Harry Guggenheim, took over the museum and the Baroness Rebay, the former curator, was replaced by my great friend James Johnson Sweeney. This was a great blessing for the museum. I had been expecting it to open sometime in the winter of 1959, and was prepared to go to New York at any moment. However, at Christmas my friends, the Cardiffs, invited me to visit them in Mexico, where Maurice Cardiff was stationed as cultural attaché to the British Embassy. I had met them in Italy, in 1948, when he was posted in Milan, and once followed them to Cyprus. I now was delighted to go to see them in Mexico, which was much more exciting than New York, though I intended to go there on my way home.

It was a most marvellous trip. Maurice and I went to Yucatan, where we saw the most fantastic ruins at Palenque, which is set deep in the jungle and really seems to be out of this world. It was so inaccessible we

could only go there by helicopter, which took us forty minutes. Then we had to make an enormous climb up many steep steps. Of everything that I saw in this one month, Palenque was by far the most exciting. The setting was wild and beautiful and the sculpture and the architecture thrilling. In fact, the ruins were more beautiful than any I have seen anywhere. After this, I went to Oaxaca, Pueblo, Acapulco, Tasco, Guernavaca and many other places. However, this is not the place to write about my trip, as I must confine myself to modern art.

Let me first of all say how much I hate the enormous frescoes of Diego Rivera, Orozco and Siqueiros that one sees in all official buildings in Mexico—and how much I like Tamayo, but even better, two remarkable women painters, Frida Kalo, Diego Rivera's wife, and Leonora Carrington, who now lives in Mexico City. She is still very beautiful, and is married to a Hungarian photographer and has two lovely little sons. She is now quite a well-established painter and her work has greatly developed. She still paints animals and birds rather resembling Bosch's, but nevertheless her work is very personal. There were no other painters of interest, though all the galleries in Mexico seemed to be flourishing.

Frida Kalo is dead and her home has been turned into a museum. I was familiar with her work, having included her in my women's shows, realizing how gifted she was in the true Surrealist tradition. Her museum was very touching and very sad. One felt how much she must have suffered in this home, where she was to die from a spinal injury caused in a motor accident in her youth, which had practically invalided her for life.

Many of her pictures dealt with physical sufferings and her various operations to cure her spinal condition, none of which were successful. We felt an atmosphere of tragedy on another plane. We saw her invalid's chair, in which she painted to the end. There could have been no love between Diego Rivera and Frida at the end of her life.

Diego Rivera, at his death, left no money to his children, who nevertheless adore him. Instead, he left a fortune to be used to build a monument to himself designed by himself. It is in the suburbs of Mexico City, in a forlorn spot surrounded by houses of poor squatters. In this pyramid, which is a bad imitation of a Mayan ruin, will be placed not only Rivera's bones, but also many of his paintings and his collection of pre-Columbian art.

When I got to New York, it was still too soon for the opening of the Guggenheim Museum. Sweeney had warned me of this, but I decided to go anyway, on my way back to Venice. Sweeney asked my cousin Harry Guggenheim to show me over the museum. I had not seen him for thirty-five years and was delighted to have this occasion to do so. I was also delighted, when I got back from Venice, to receive a letter in which he said:

'Before your arrival, and before we had a chance to become reacquainted after all these years, I had the general feeling that perhaps some day you might want to leave your collection to the Foundation to be housed in the new Frank Lloyd Wright Museum. However, after thinking the matter through, I most sincerely believe that your Foundation and your palace, which has, thanks to your initiative, become



world-renowned, should, after your death, be bequeathed, as you have planned, to Italy. I think that is the appropriate place for it, and I think from the family point of view—which I confess is always uppermost in my mind, this plan would be the most beneficial. I do hope while you were over here you were able to make progress with your plans.

'May you continue, in great success, in your life dedicated to the progress of art, and also get lots of pleasure and fun from it.'

Harry seemed to take his responsibilities very seriously and obviously had had great difficulties as a buffer between what he referred to as 'two egotistical geniuses', Sweeney and Wright, the latter then a very old man. I did not envy Harry his position, but I completely sided with Sweeney against Wright who, I am certain, like Kiesler, was not interested in the pictures, but only in his architecture.

Two people could not have been more at loggerheads than Sweeney and Wright. Poor Sweeney, who inherited this millstone along with his job as director of the museum, is an absolute purist about display—in fact, he is a fanatic. The interior of his home resembles a Mondrian painting. Luckily Wright died while I was in New York, and I presume this cleared the air and left Sweeney with less difficulties.

The museum resembles a huge garage. It is built on a site that is inadequate for its size and looks very cramped, suffering from its nearness to adjacent buildings. It should have been placed on a hill in the Park; instead it is on the wrong side of Fifth Avenue. Around an enormous space intended for sculpture displays, the

rising ramp, Wright's famous invention, coils like an evil serpent. The walls bend backward, and a cement platform keeps one at a respectful distance from the pictures. Nothing could be more difficult than viewing them at this angle. Eventually they will be placed on brackets extending from the walls. It is amazing how Kiesler's ideas have been copied. The colours were very ugly, beige in some places, white in others. But I felt, somehow, that Sweeney with his genius would eventually overcome all the difficulties and the museum would be all right. Nevertheless, I much preferred my modest *barchessa* in Venice, and for the first time I did not regret the enormous fortune I had lost when my father left his brothers to go into his own business, a few years before he was drowned on the *Titanic*.

My best day in America was spent visiting the Barnes collection and the Philadelphia Museum, ending up for cocktails in the modern apartment of Ben Heller, the art collector. Rather a heavy programme for one day, which also included a midnight party.

I was escorted to the Barnes Foundation by my friend Robert Brady, who had once been a pupil there. He obtained a special invitation for me, as I was leaving in a few days. He was not admitted with me, as his invitation was for a fortnight later. It was the first time that I had asked to visit the collection. The house, situated in a lovely park, is not very large or modern, but this marvellous collection is unbelievable. The place is not in any way considered as a museum. The pictures are intended to be shown only to art students and are taken down from the walls when being studied. Miss Violette de Mazia presides as hostess and teacher. She was very kind and hospitable, but when I asked her for a catalogue

she seemed very shocked. It took half an hour to get used to the arrangement of the pictures. I have never seen so many masterpieces assembled in such confusion, at times five rows deep. There were about twenty small rooms, apart from the large hall. Here, in a gallery above, there was a large series of paintings by Matisse, done specially for the space. One had to concentrate with all one's will-power to look at each picture in turn, as the surrounding ones were so close. There were about two hundred and forty Renoirs, one hundred and twenty Cézannes, forty-three Matisses, thirty Picassos, twenty Douanier Rousseaus, twelve Seurats, twenty-five Soutines, as well as paintings by Modigliani, Manet, Monet, Daumier, Van Gogh, Courbet, Klee, Vlaminck, Degas, Jean Hugo, Laurens, Utrillo, Braque, and Derain. There were also some old masters, like Titian, Tintoretto, Cranach, van de Velde and Franz Hals. Another room contained old American furniture, and another was filled with pre-Columbian sculpture and jewellery. The walls were dotted everywhere with early-American wrought-iron arabesques. I was permitted to remain two hours, though I could have stayed a month. I went around two or three times, and at the end Robert Brady slipped in unnoticed.

Completely exhausted and overwhelmed by what I had seen, I nevertheless proceeded to the Philadelphia Museum to see the Arensberg and Gallatin collections in their new setting. I was enormously impressed by Henry Clifford's installation. Apart from this, the museum had innumerable other treasures and I wandered around through a part of the Indian temple of Madura, a Chinese palace hall, a Japanese tea-house, a Japanese scholar's study, the cloister of St Michel de

170

Cuxa, from Toulouse, the fountain of St Genis des Fontaines, as well as Italian, French and English interiors, all brought to America like the Scottish castle in the Robert Donat movie, *The Ghost Goes West*.

After such a day, it seemed a fitting climax to take cocktails surrounded by Pollocks, Philip Gustons, Stamos, Rothkos, in the home of Mr and Mrs Ben Heller and in the company of Mr and Mrs Bernard Reis, outstanding collectors themselves, and with Lee Pollock. The Hellers' apartment is dedicated to their collection. They have taken down walls in order to make space for Pollock's fabulous painting called 'Blue Poles'. In fact, they moved from a lovelier place, because here, on Central Park West, they have more room. The flat is so bare that it looks half-way between a sanctuary and a hospital. This is the prescribed way of life for those who dedicate themselves to modern art, and the Hellers are not the only victims.

In the twelve years I had been away from New York everything had changed. I was thunderstruck, the entire art movement had become an enormous business venture. Only a few persons really care for paintings. The rest buy them from snobbishness or to avoid taxation, presenting pictures to museums and being allowed to keep them until their death, a way of having your cake and eating it. Some painters cannot afford to sell more than a few paintings a year, as now they are the people to be taxed. Prices are unheard of. People only buy what is the most expensive, having no faith in anything else. Some buy merely for investment, placing pictures in storage without even seeing them, phoning their gallery every day for the latest quotation, as

171

though they were waiting to sell stock at the most advantageous moment. Painters whose work I had sold with difficulty for six hundred dollars now received twelve thousand. Someone even tried to sell me a Brancusi head for forty-five thousand dollars. Lee Pollock kept all Pollock's paintings in storage and did not even want to sell to museums.

I could not afford to buy anything that I wanted, so I turned to another field, that is, after a few artists were very kind to me and made me special prices. I began buying pre-Columbian art. In the next few weeks I found myself the proud possessor of twelve fantastic artefacts, consisting of totem poles, masks and sculptures from New Guinea, the Belgian Congo, the French Sudan, Peru, Brazil, Mexico, and New Ireland. It reminded me, in reverse, of the days after Max had left our home, when he came back in the afternoons, while I was in the gallery, and removed his treasures one by one from the walls. Now they all seemed to be returning. I even succumbed to the dangerous little Mr Carlebach, who had formerly sold so many things to Max in New York, and who now had a magnificent gallery on Madison Avenue. His prices had doubled, but at least they were still possible.

For several years Clement Greenberg had said that when I came back to New York he would like to make a show called 'Hommage a Peggy', to include all my 'war babies', as I called the painters I had discovered during the war. It was to have been a huge exhibition launched with a champagne party. But I had to decline. Greenberg had become artistic adviser to French and Company, where it would have to have been held, but I

did not like what they exhibited in their galleries, nor what most of my 'war babies' were now painting. In fact, I do not like art today. I think it has gone to hell, as a result of the financial attitude. People blame me for what is painted today because I had encouraged and helped this new movement to be born. I am not responsible. Eighteen years ago there was a pure pioneering spirit in America. A new art had to be born—Abstract Expressionism. I fostered it. I do not regret it. It produced Pollock, or rather, Pollock produced it. This alone justifies my efforts. As to the others, I don't know what got into them. Some people say that I got stuck. Maybe it is true. I think this century has seen many great movements, but the one which undoubtedly stands out way beyond all the others is the Cubist movement. The face of art has been transformed. It is natural that this should have come about, as a result of the industrial revolution. Art mirrors its age, therefore it had to change completely, as the world changed so vastly and so quickly. One cannot expect every decade to produce genius. The twentieth century has already produced enough. We should not expect any more. A field must lie fallow every now and then. Artists try too hard to be original. That is why we have all this painting that isn't painting any more. For the moment we should content ourselves with what the twentieth century has produced —Picasso, Matisse, Mondrian, Kandinsky, Klee, Léger, Braque, Gris, Ernst, Miró, Brancusi, Arp, Giacometti, Lipchitz, Calder, Pevsner, Moore and Pollock. Today is the age of collecting, not of creation. Let us at least preserve and present to the masses all the great treasures we have.

173

INDEX

174

9 780880 015769

Made in the USA
Las Vegas, NV
05 March 2021